THIS PLACE, THESE PEOPLE

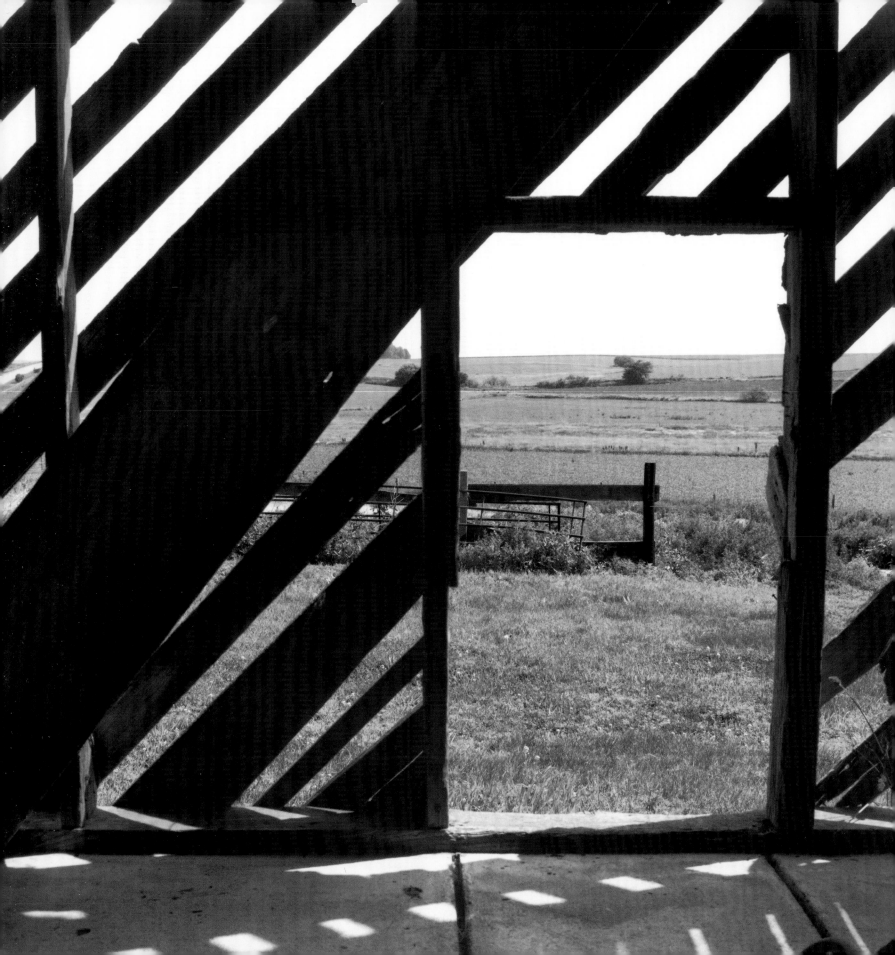

THIS PLACE, THESE PEOPLE

LIFE AND SHADOW ON THE GREAT PLAINS

PHOTOGRAPHS BY **NANCY WARNER** TEXT BY **DAVID STARK**

COLUMBIA

UNIVERSITY

PRESS

NEW YORK

Columbia University Press
Publishers Since 1893
New York Chichester, West Sussex
cup.columbia.edu
Copyright © 2014 David Stark and Nancy Warner
All rights reserved

Library of Congress Cataloging-in-Publication Data
Warner, Nancy, 1951–
This place, these people : life and shadow on the Great Plains /
photographs by Nancy Warner ; text by David Stark.
 pages cm
Photographs by Nancy Warner accompanied by the words of
Nebraska farmers and residents.
ISBN 978-0-231-16522-8 (cloth : alk. paper) — ISBN 978-0-
231-53627-1 (electronic)
1. Nebraska—Pictorial works. 2. Farm life—Nebraska—Pictorial
works. 3. Nebraska—Rural conditions—Pictorial works. I. Stark,
David, 1950– II. Title.
F667.W37 2013
978.2—dc23
2013000946

Columbia University Press books are printed on permanent
and durable acid-free paper.

This book is printed on paper with recycled content.
Printed in Canada
c 10 9 8 7 6 5 4 3 2 1

Cover photograph: Nancy Warner
Cover and book design: Lisa Hamm

References to websites (URLs) were accurate at the time
of writing. Neither the author nor Columbia University Press
is responsible for URLs that may have expired or changed
since the manuscript was prepared.

*Columbia University Press would like to express
its appreciation for assistance given by*

*Furthermore: a program of the J. M. Kaplan Fund
in the publication of this book.*

To our family ↔

In all my life I've never seen anything so crowded,
so full of something, as the rooms of a vacant house.

↔ WRIGHT MORRIS, *The Inhabitants*

CONTENTS

PREFACE

AROUND THE TIME this book went into production, I read the essay "Small Rooms in Time" by Ted Kooser, the Nebraskan poet. This sentence struck me: "I began to think about the way in which the rooms we inhabit, if only for a time, become unchanging places within us, complete in detail."

The photographs in this book tell stories of different farm places. I made them between 2001 and 2008, in and around Cuming County, Nebraska, where my great-grandfather homesteaded and my parents grew up. People in the area helped me find and get access to many of the places. They were amused and curious about why these old broken-down buildings warranted so much of my attention. In 2008 I installed the first large exhibit of the series at the Great Plains Art Museum in Lincoln. The photographs evoked strong emotional reactions from viewers. During this and subsequent exhibit receptions, people approached me with memories and stories triggered by details in the images.

My cousin David Stark first learned of the project when *Black & White* magazine published a selection of the photographs and an interview with me. He was intrigued. During a visit he made to San Francisco in 2010, we got the idea to collaborate on this book. We traveled to Nebraska then, and again in 2011. We sought out and talked to relatives and other people in Cuming County, most of whom had lived in these places. The book began to take shape.

Those voices are recorded here just as David heard them. The pairings of the photographs with the text are based not on specific stories, or even their connections with the places shown, but on the *voices* themselves: the sounds, rhythms, and emotions that seemed to best set off the feeling of each photograph.

No single photograph, story, or voice can entirely capture the farming way of life, or the American way of life. So as you look through this book, I hope you will rediscover within yourself some of the rooms and places you once inhabited—complete in detail.

Nancy Warner, January 2013

PHOTOGRAPHS & VOICES

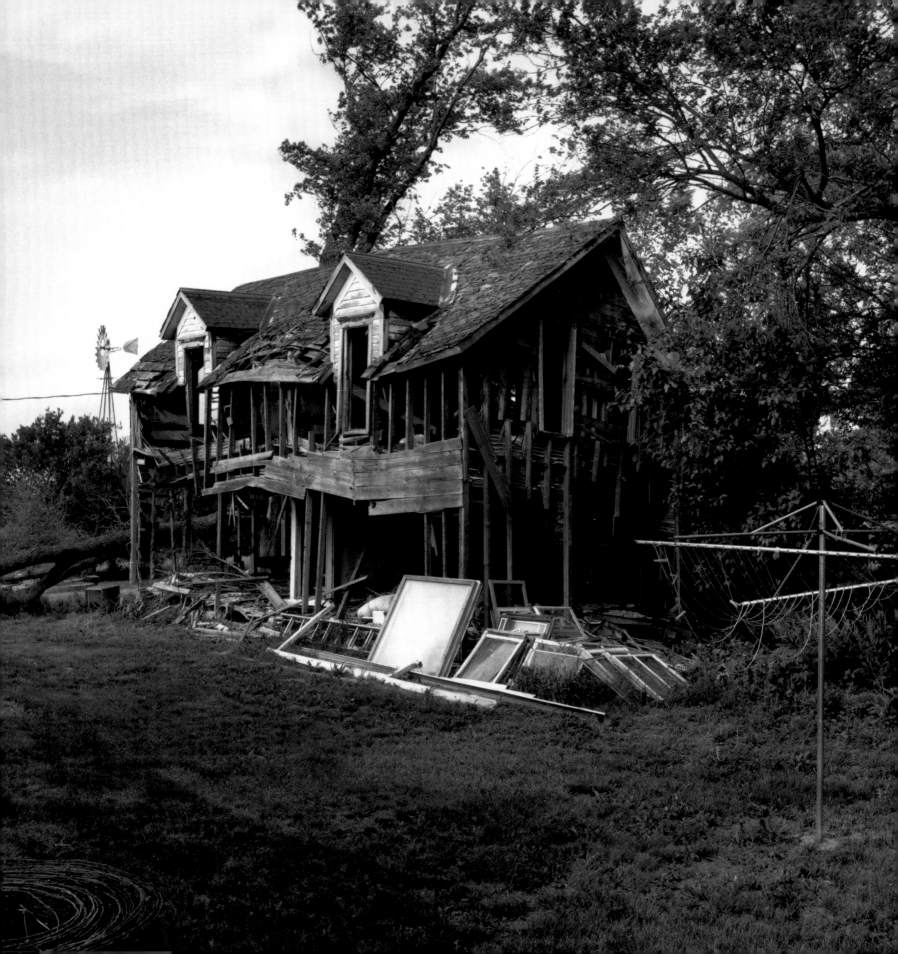

We wrapped a chain around that house
and hitched it to a tractor, but we couldn't
bring it down.

We'd pulled off the boards about waist high
and cut notches on all these beams
here and here and here, wrapped the chain
all around it at the notches.

The tractor died, the house didn't.

That tractor groaned and wheezed, but it died
and we couldn't get it started again. It was
a tough old tractor, but an even tougher house.

That was about five years ago. There've been
wind storms you would think would've done it,
but nothin's bringing that house down.

It's still there.

↦ Les

We had chairs lined up across the way—
not too close, we didn't want anybody
to get hurt. I don't know how many chairs,
but it must have been a bunch because
all kinds of people were here.
I can't think now who was all here.
I know the neighbors came over
for the big show. Nothing happened.

↦ Ferny

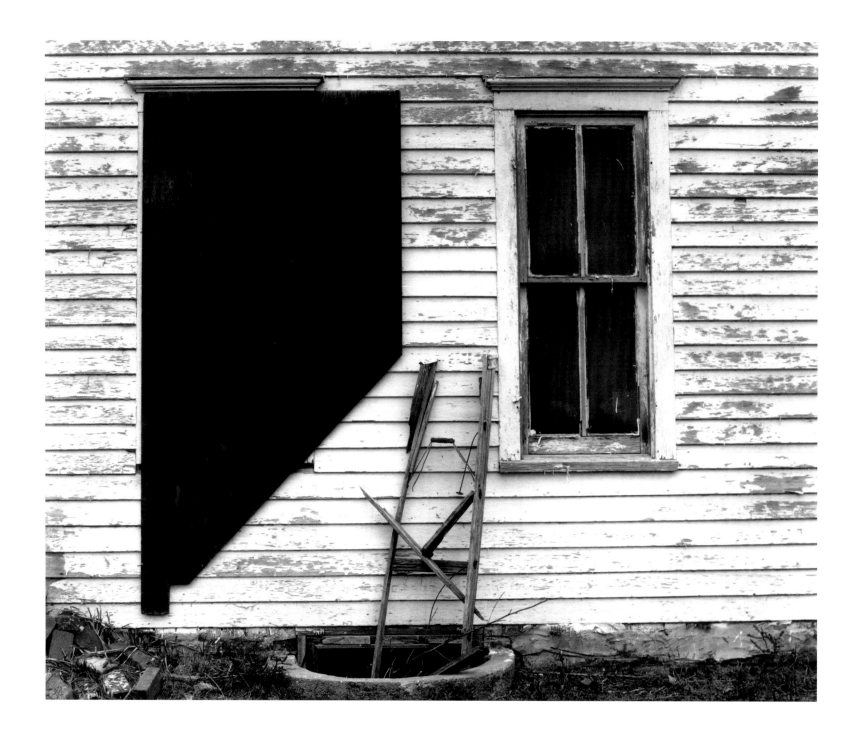

We raised hogs, farrow to finish,
from babies to the butcher.
Those sows would be having babies,
but I'd want to go bowling.
So I'd reach right in and pull
those babies out. I didn't care.
I wanted to go bowling.

I liked my pigs. People think
they're ugly. But I liked my pigs.

↔ Marian

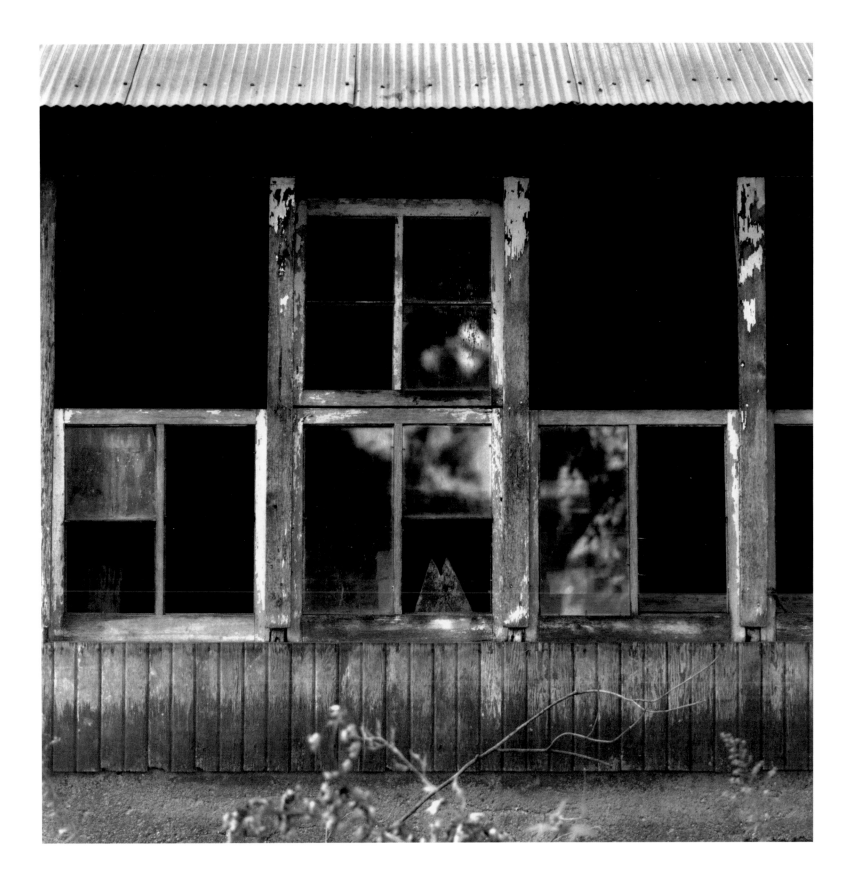

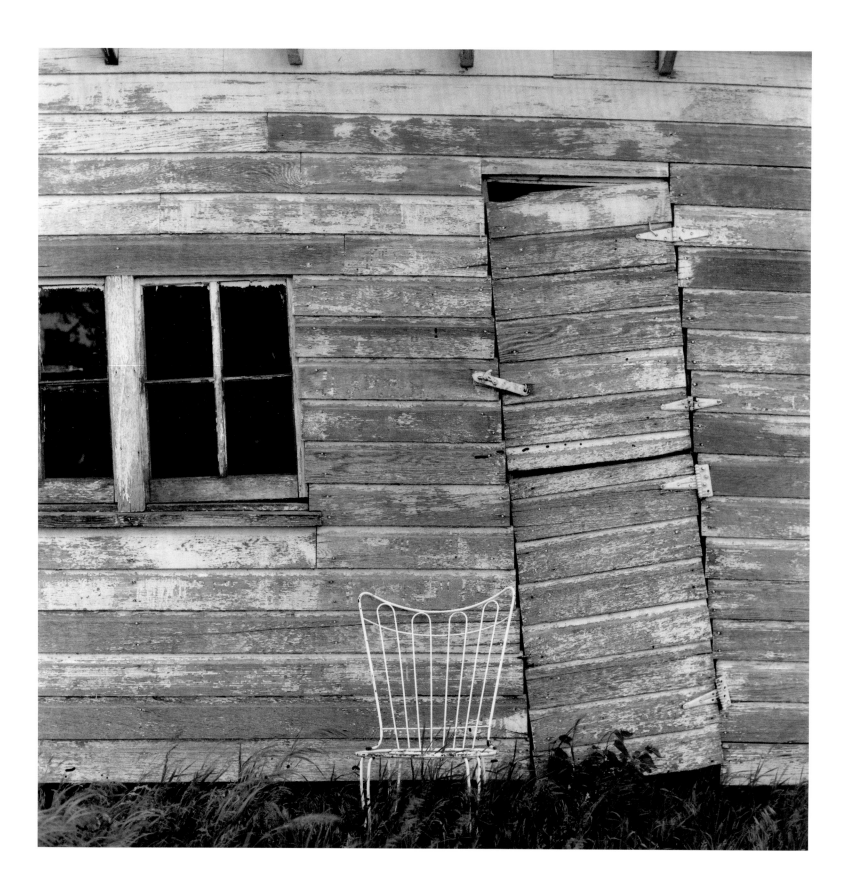

Dad had me on a tractor from real early. He didn't care if I was young. He had me on that tractor. I couldn't've been ten. He went, Get on that tractor and drive it over here. I must've watched my brother from riding on the tractor with him, because I managed to get it moving.

I started raking hay. Later I drove the sweep for sweeping up hay. We had an old-time sweep. They'd taken an old car, stripped it down to the frame, engine, and gearbox, converted it to front-wheel drive, and put the seat and steering wheel in the back, like a combine with the sweep out in front. That thing would go. I loved that. It drove like a car and it went so fast. You could drive this way and that.

I suppose it'd been smarter to just go down your row. But you know. . . . And by the time you'd pretty much finished the field, there'd be spots here and there that you'd need to race all over to sweep up.

That was fun. That was about my favorite job ever.

↦ Kathy

9

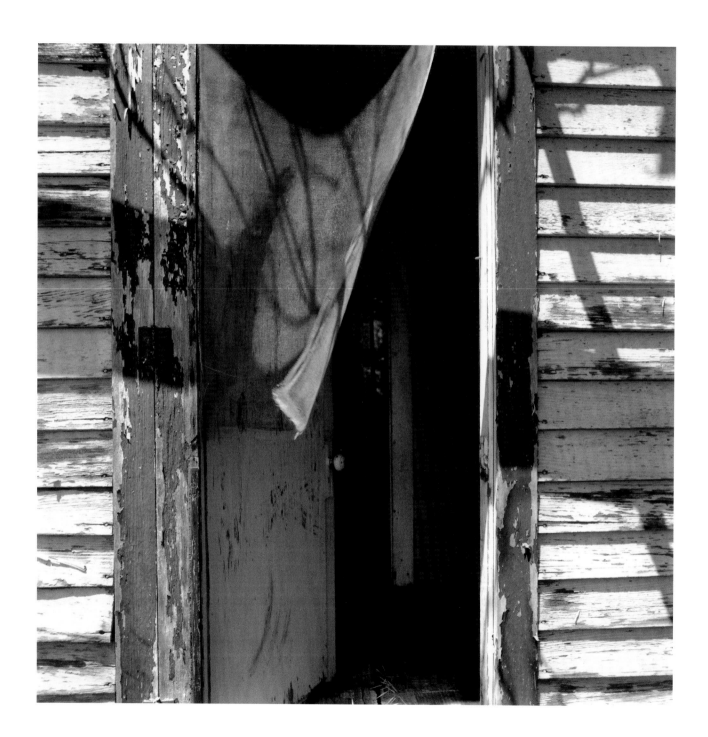

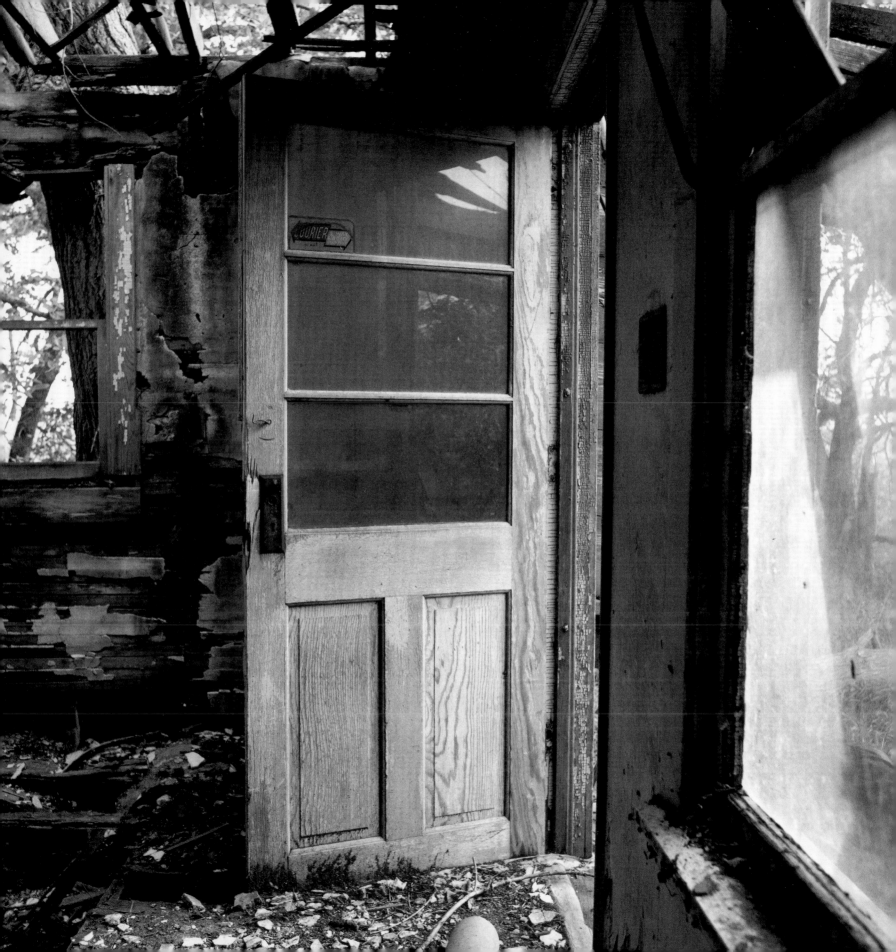

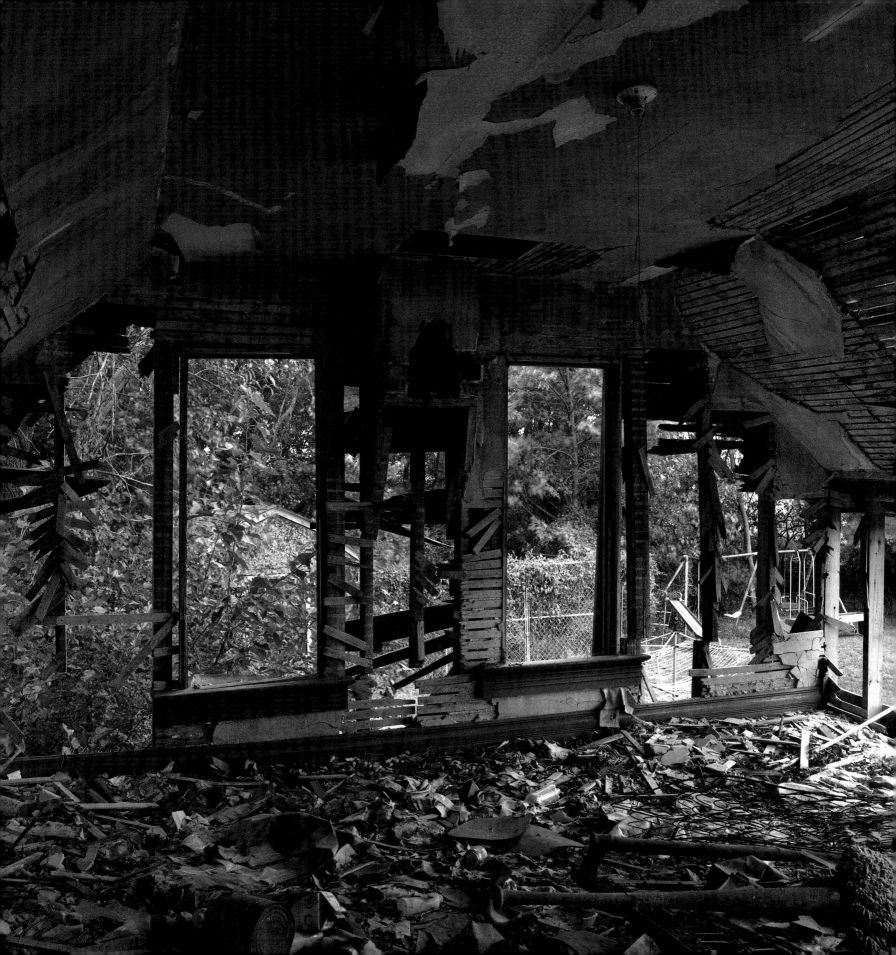

These old barns and such were built to last,
with lumber that was from older trees than
what you find today.

And, pardon my language, but none of this
1 x 3 crap.

A 2 x 4 was a 2 x 4, as you can see if you go into
some very old barn and measure the lumber.

↔ Gayle

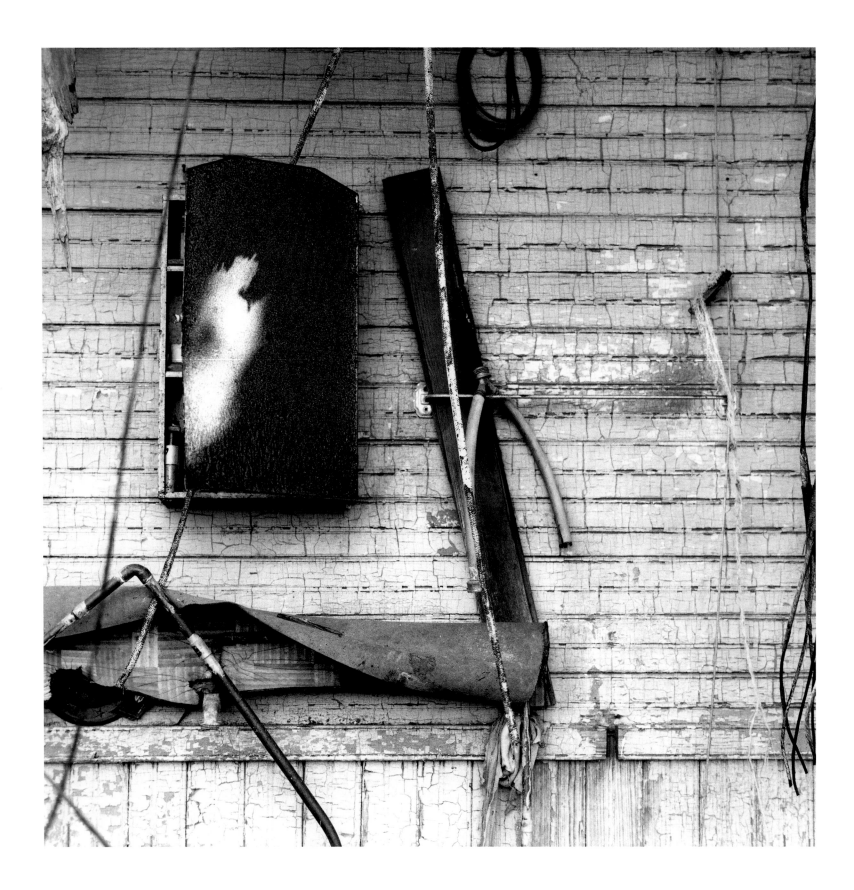

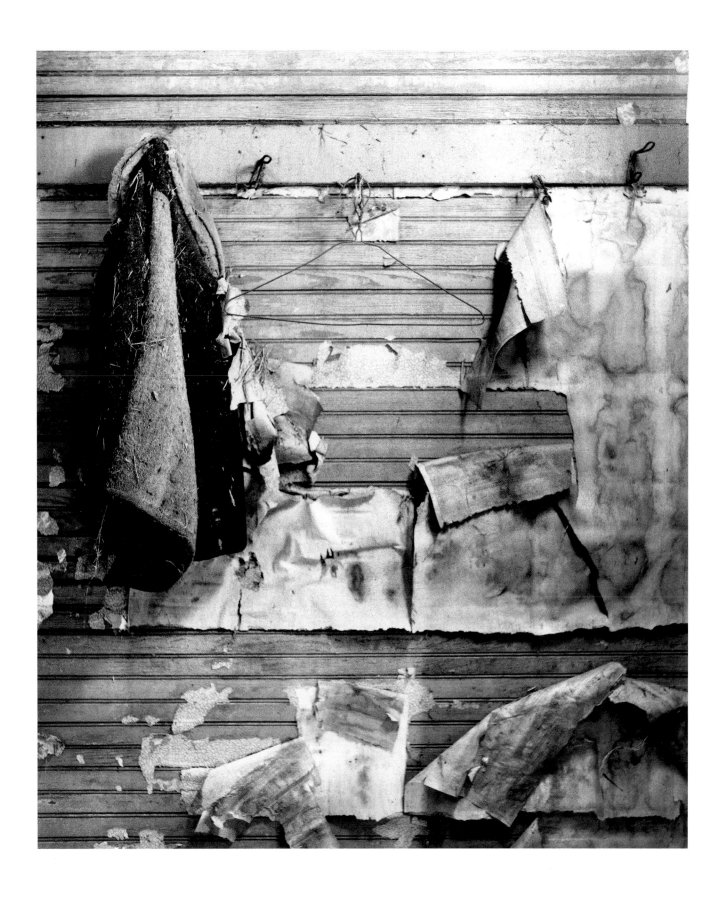

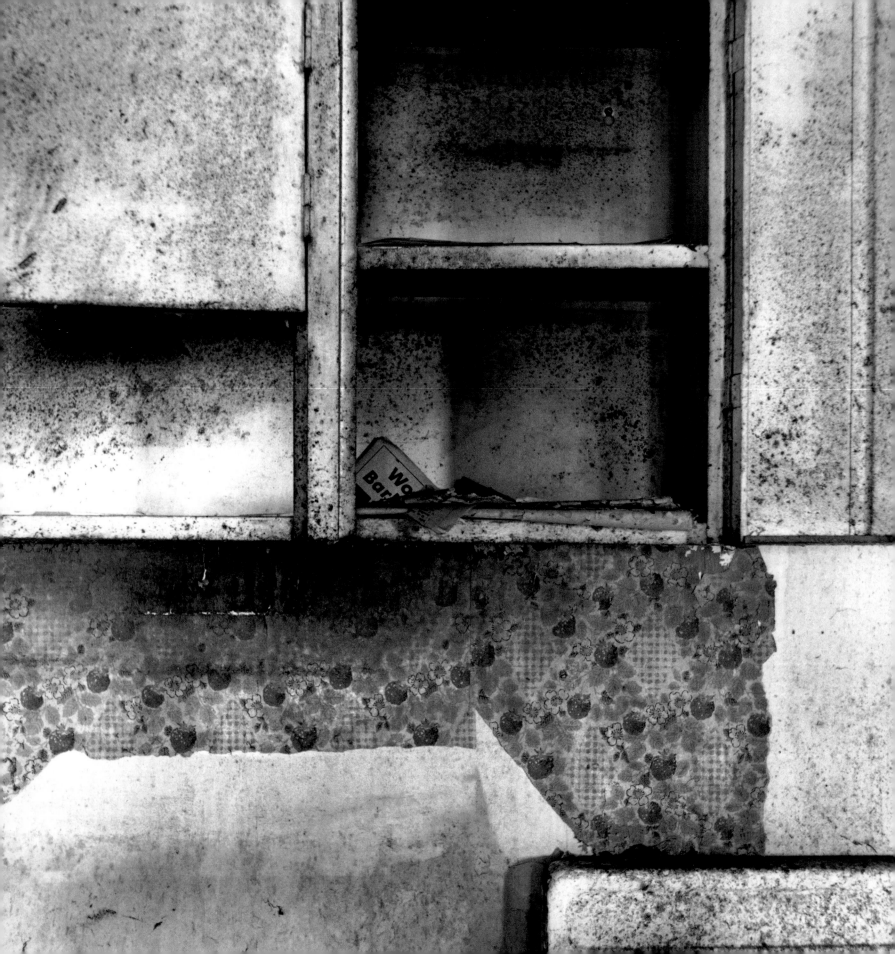

This is the fifth year I've planted this field.
Each time I learn something more about it.

That darker spot over there has more silt.
That's good, but it can also be a mess if you get
too much rain. Up over here by this hill you see
that the soil's got more clay. That's not so good,
but on the other hand, it can retain more water.

My dad says you want to have a feel for a field.
You come to an understanding with it.

↔ James

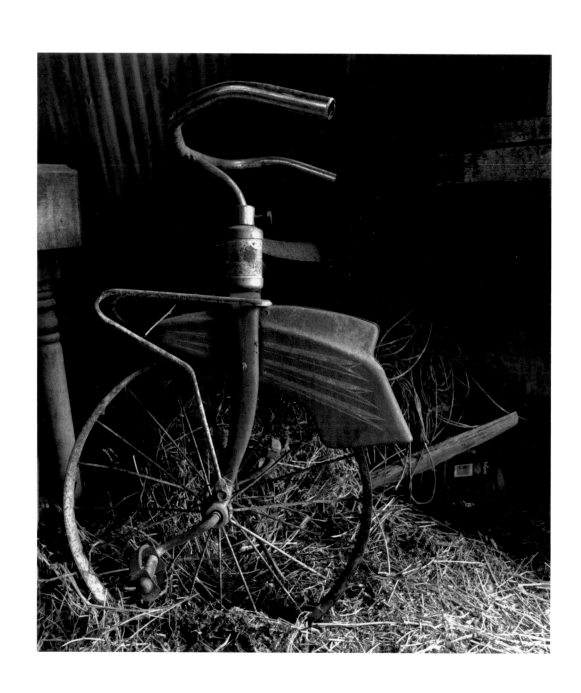

What's in those old buildings?
In that one old shed, we've got two
ancient tractors. In that old corncrib,
it's just junk. All kinds of stuff, just junk.
I'd say it's for that junk that those old
buildings are still standing.

↔ Bonnie

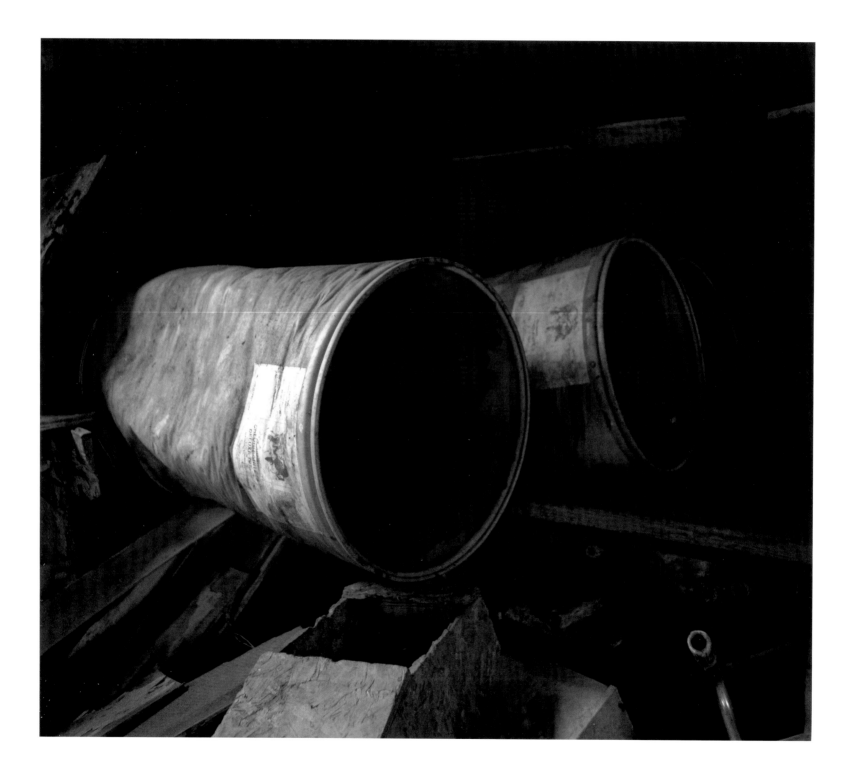

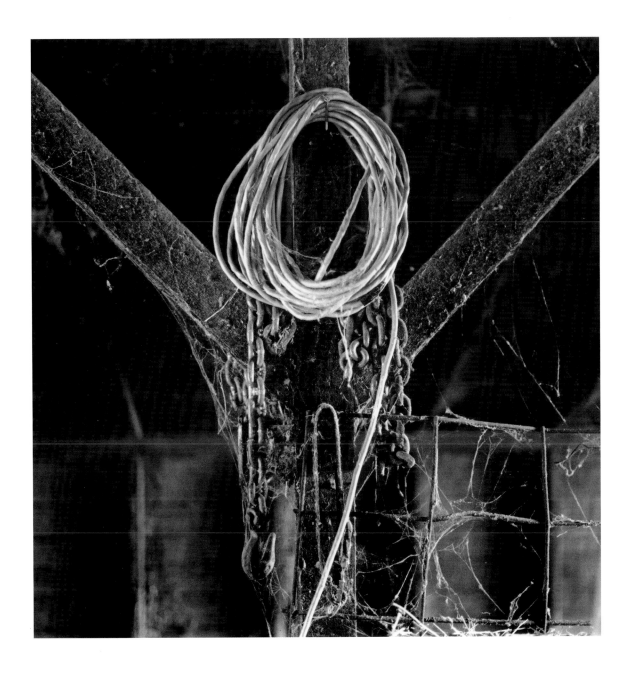

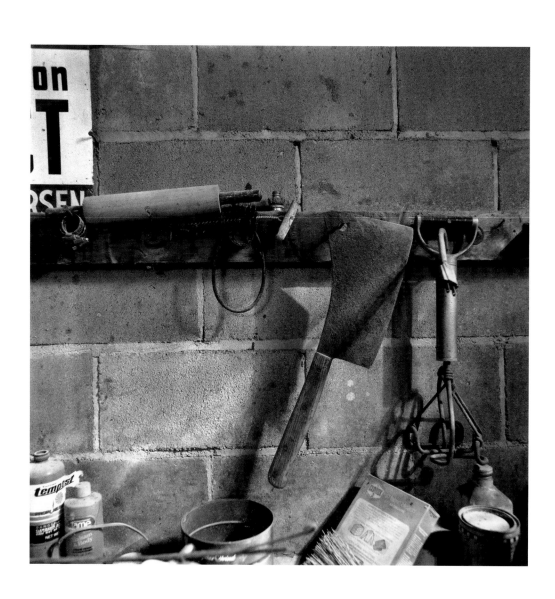

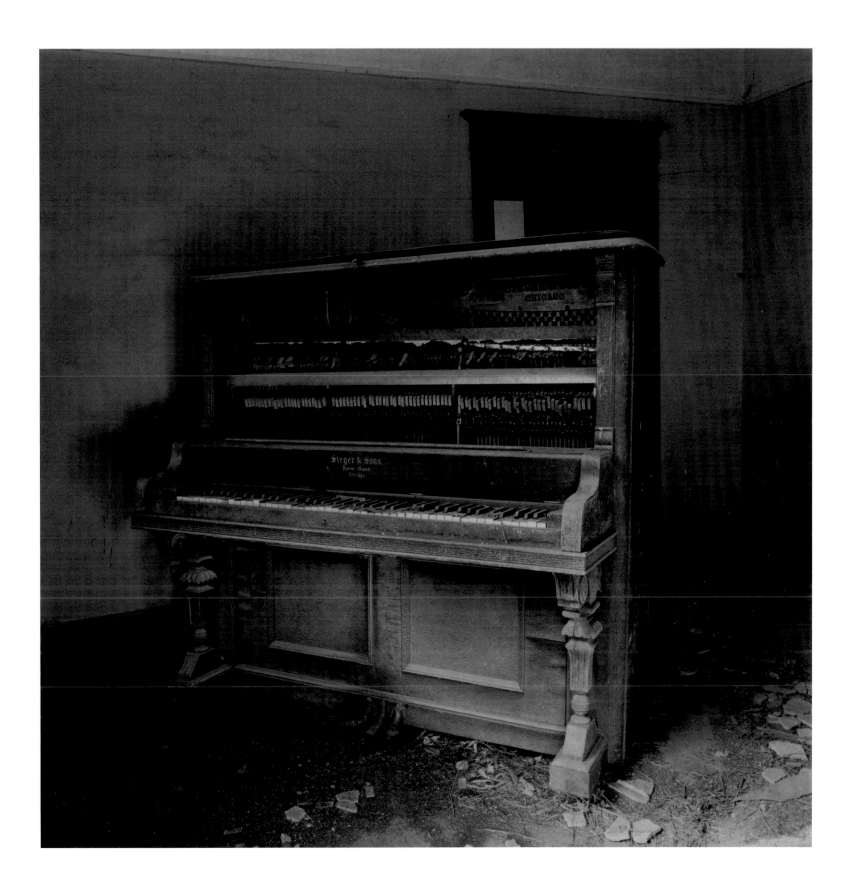

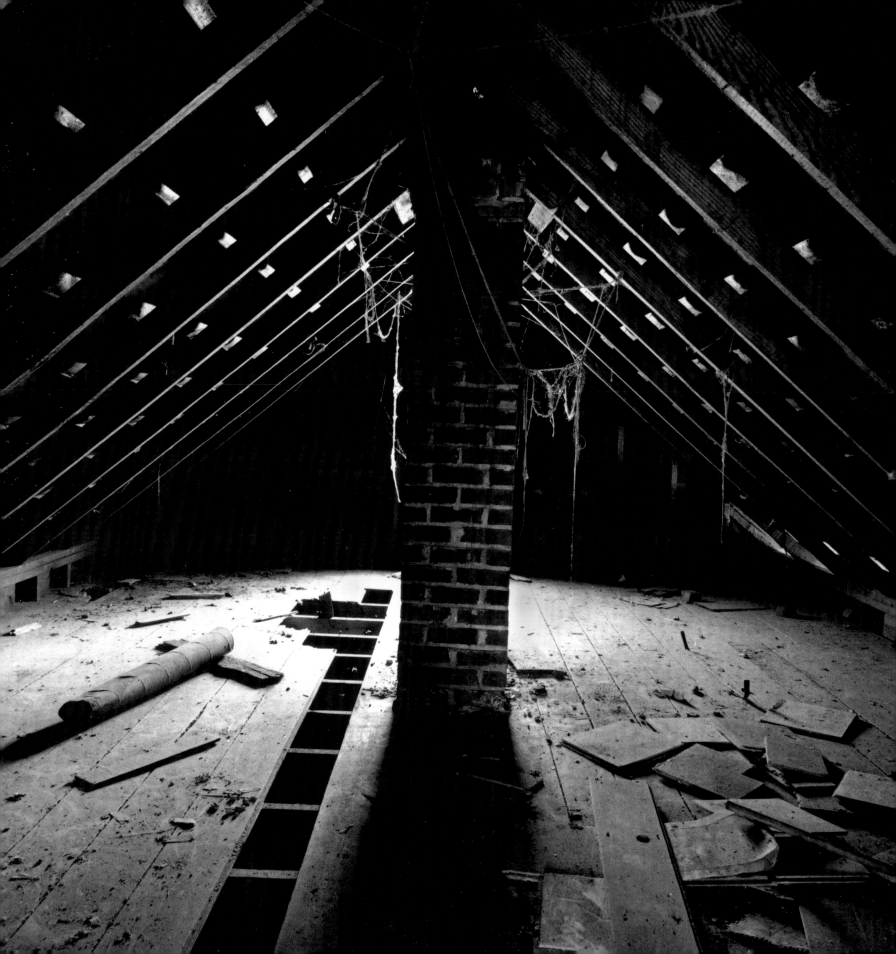

With farming it can be really good. But it can
be bad. There's so much that can't be predicted.
There's the weather. Obvious. But then
there's the markets. And not just one but a lot
of different markets that are affecting the price
of your corn. What is China doing?
What's happening when the mutual funds and
hedge funds get heavier into commodities?

And you've got these material science
people who are coming up with more and
more nonfood uses for corn every year.
Who knows what's next?

I get texts about markets right out here
on my mobile. I went online and subscribed.
I've got corn and bean prices.

I think that the best is to try to keep my debts
low. But this is farming, and it just seems that
debt and farming go together.

↔ James

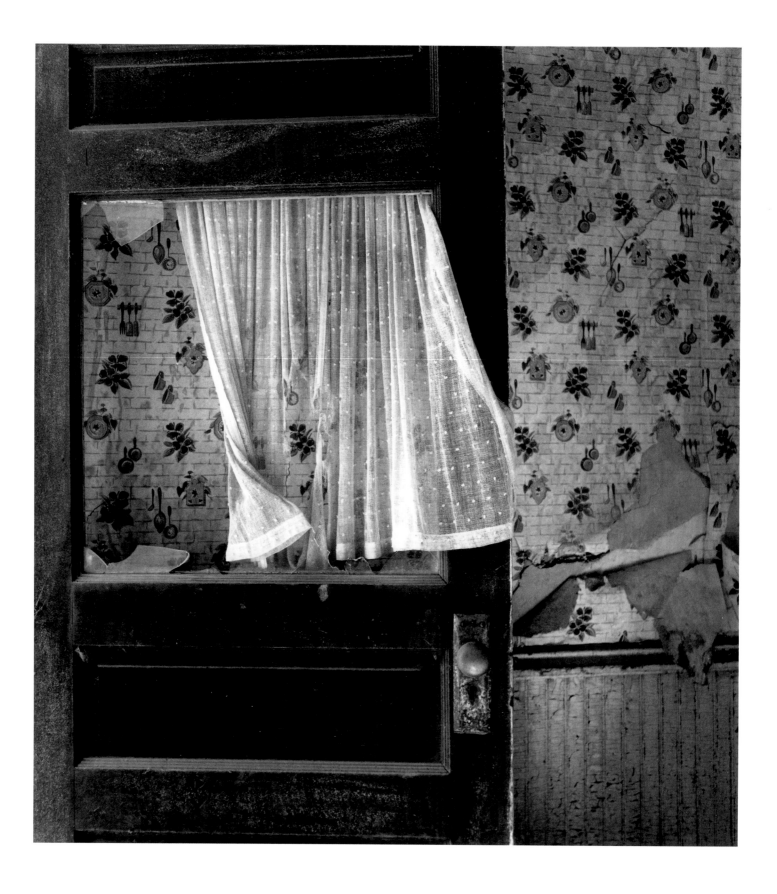

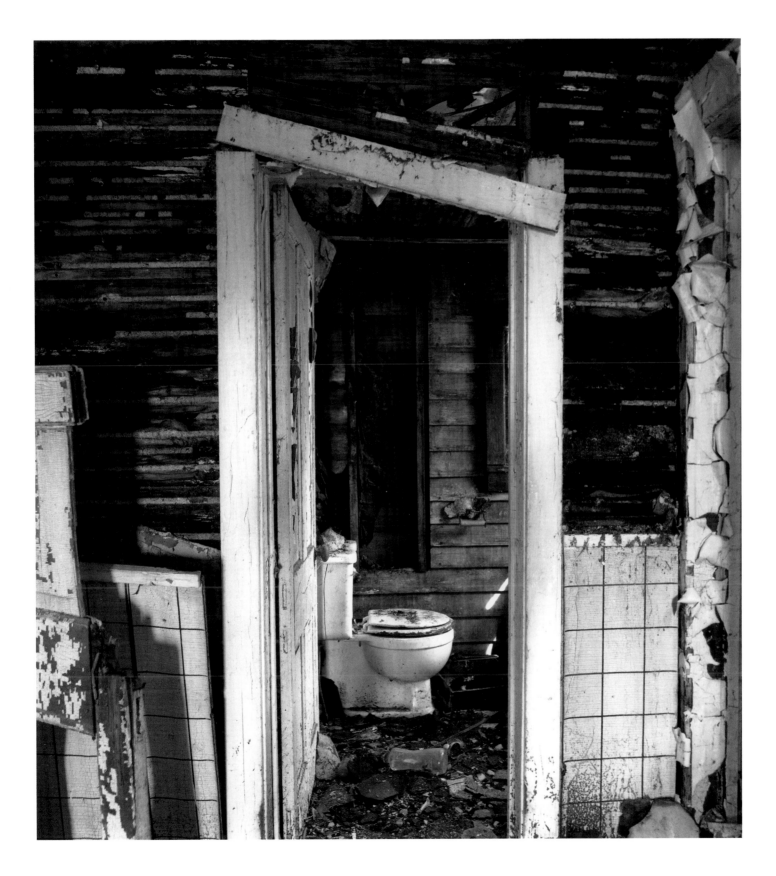

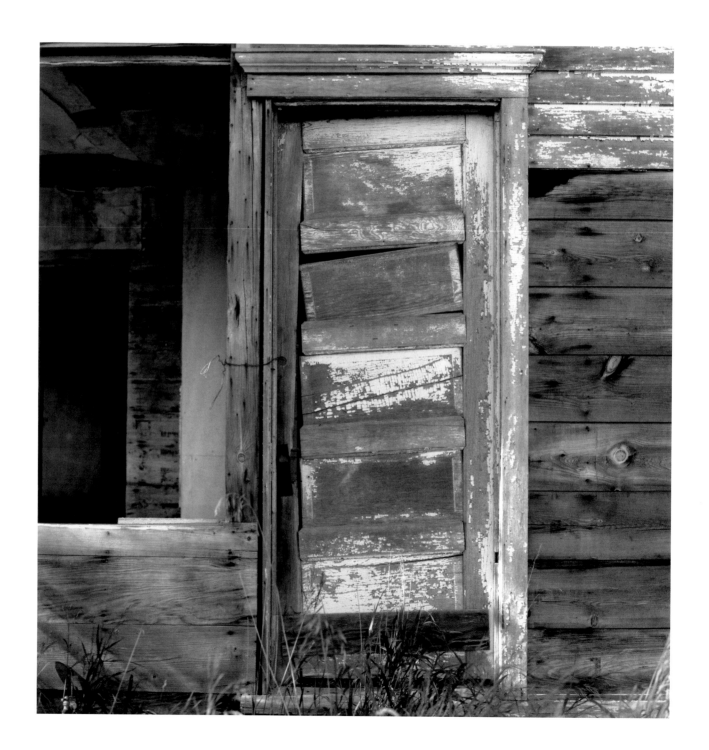

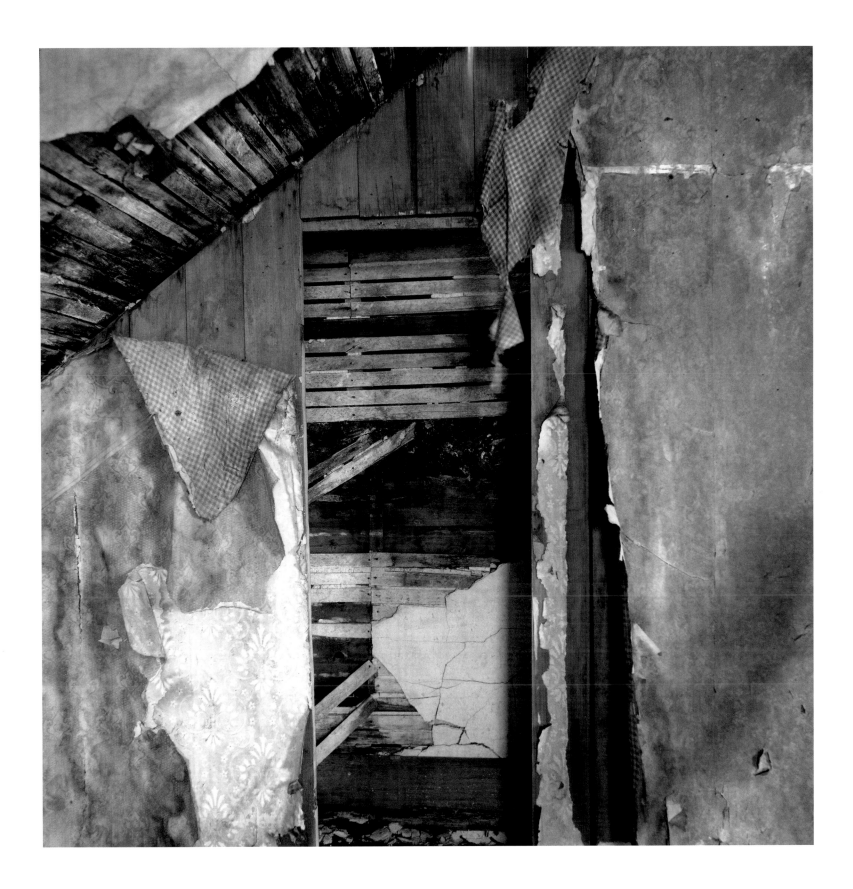

They first lived in a dugout house.
You know, cut into a hill.
The lady couldn't stand the bedbugs
and fleas.

She was from Germany.
She wanted to go back to Germany.

So her husband built her a big brick house.

↔ David

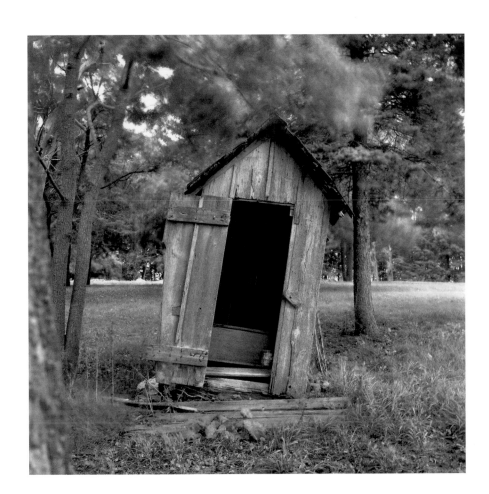

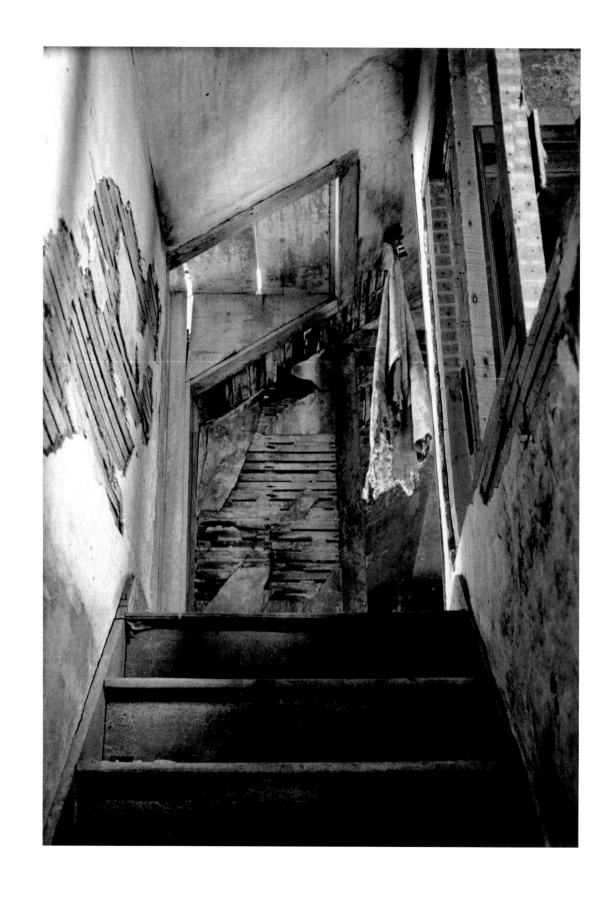

That was a "sent-for" house. They ordered it
from the Sears Roebuck catalog. One of those
T-style houses.

They spotted that house so they could look out
and see all three quarter-sections.

You want to see the fruits of your labor.

↪ David

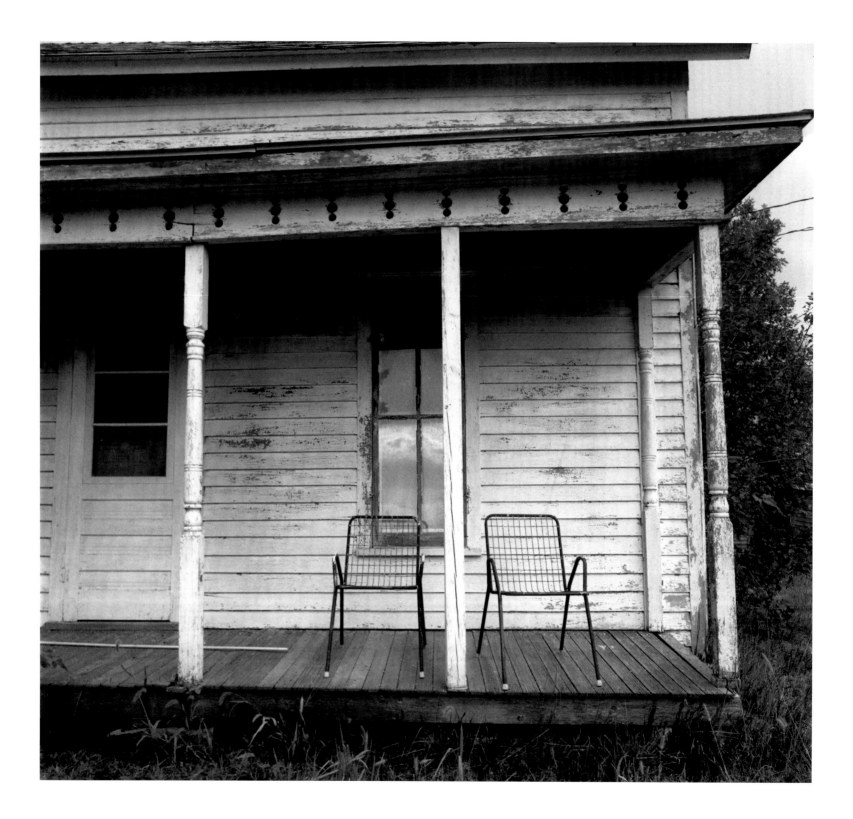

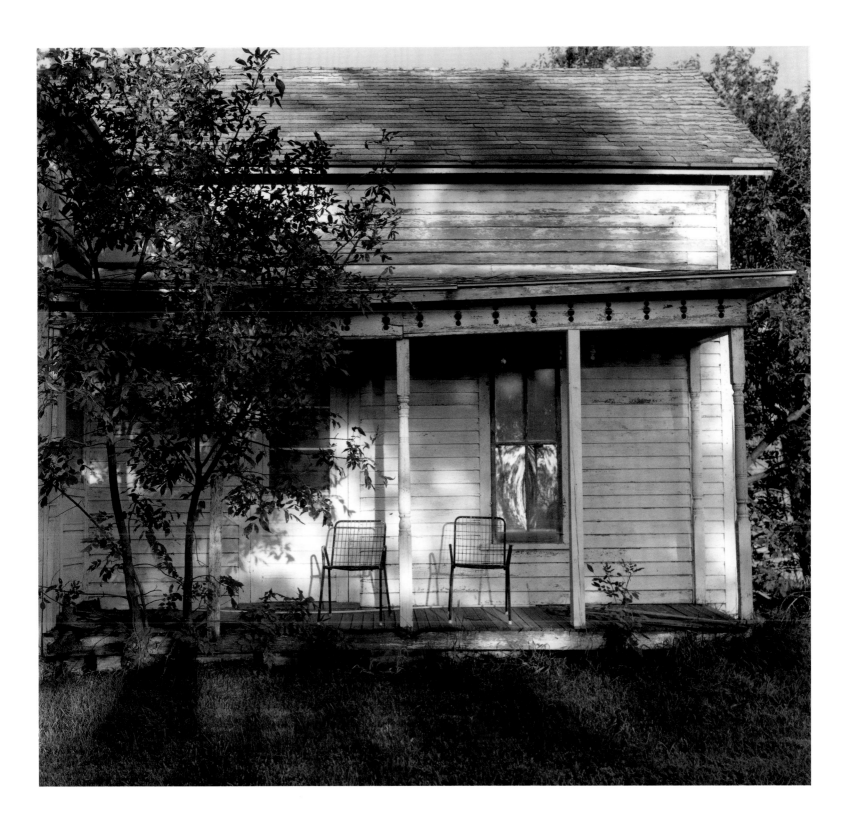

My grandfather didn't have to go far to find his wife. Just one mile down the road. That was pretty common in these parts.

They didn't call it that, but there were arranged marriages. This family with that family. Kind of like biblical times.

She's worth three camels and two goats. But with property involved.

↔ David

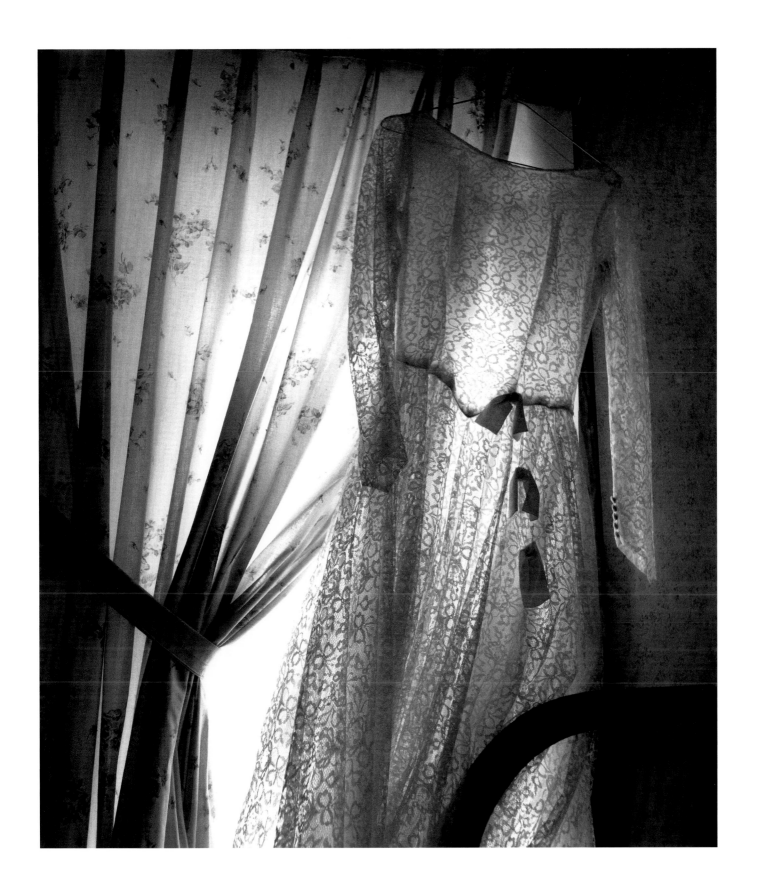

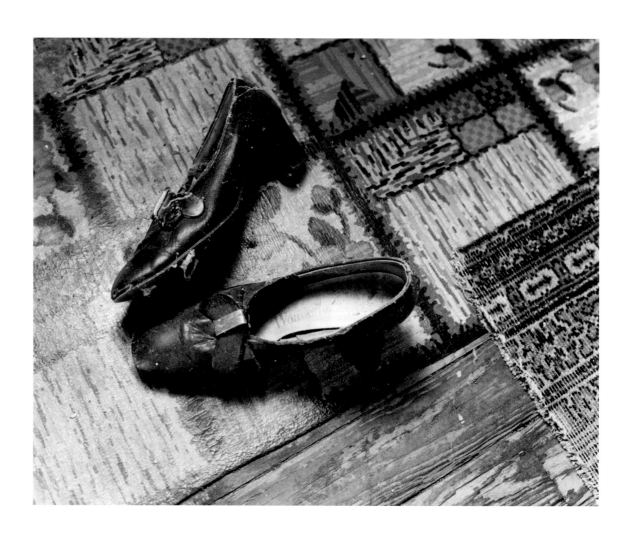

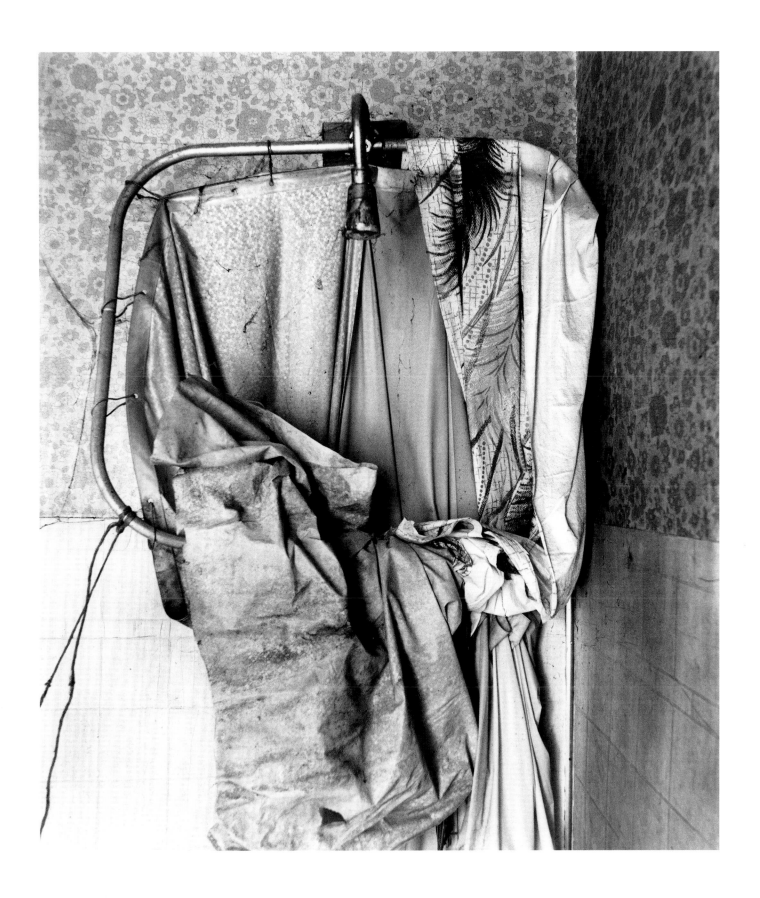

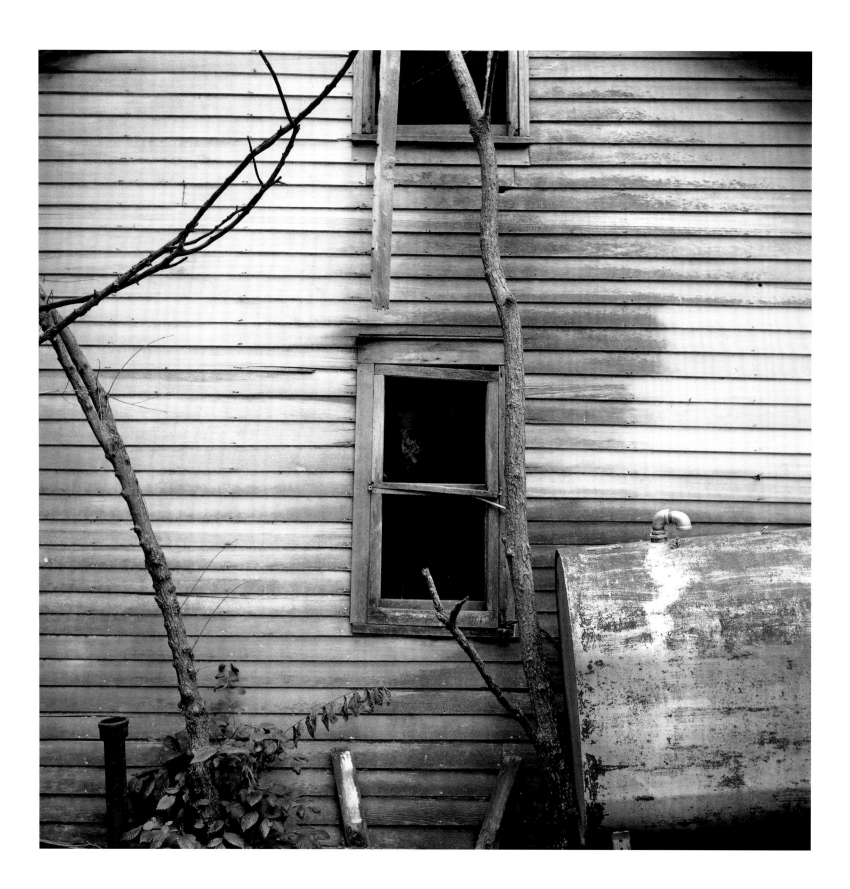

After we first got married,
we lived in a brooder house.
That's where they'd raised chickens.
A brooder house. We lived in that
house till the stove blew up.
I was carrying Rodger. I tripped.
But we made it to my in-laws'.

↔ Ferny

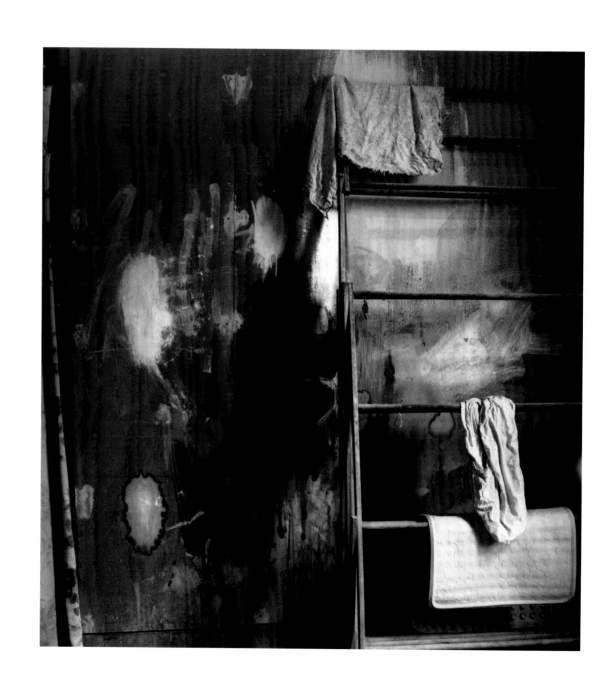

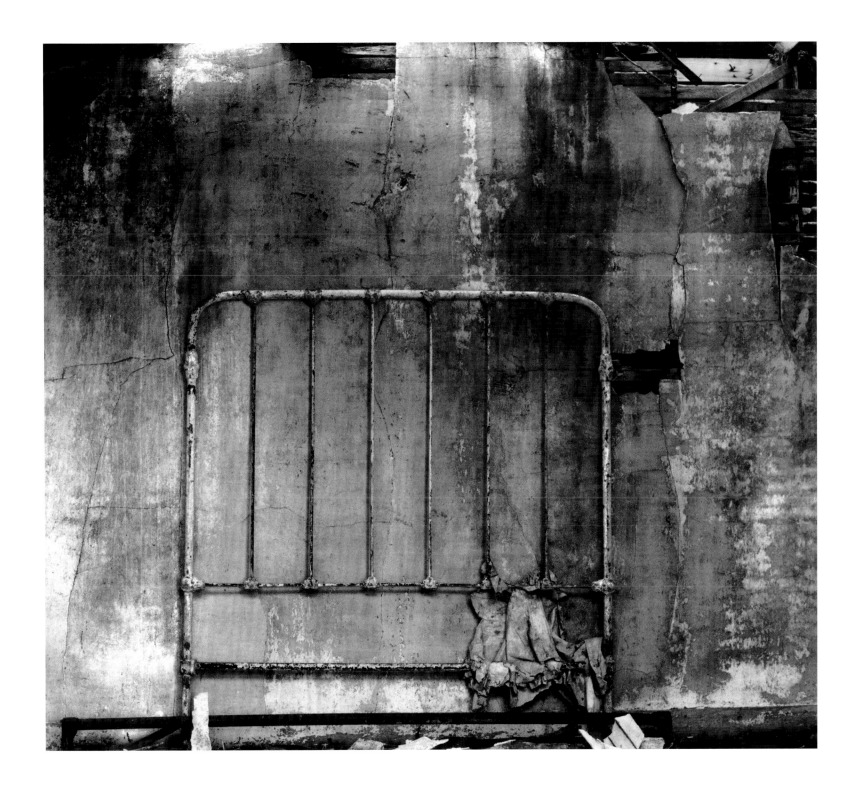

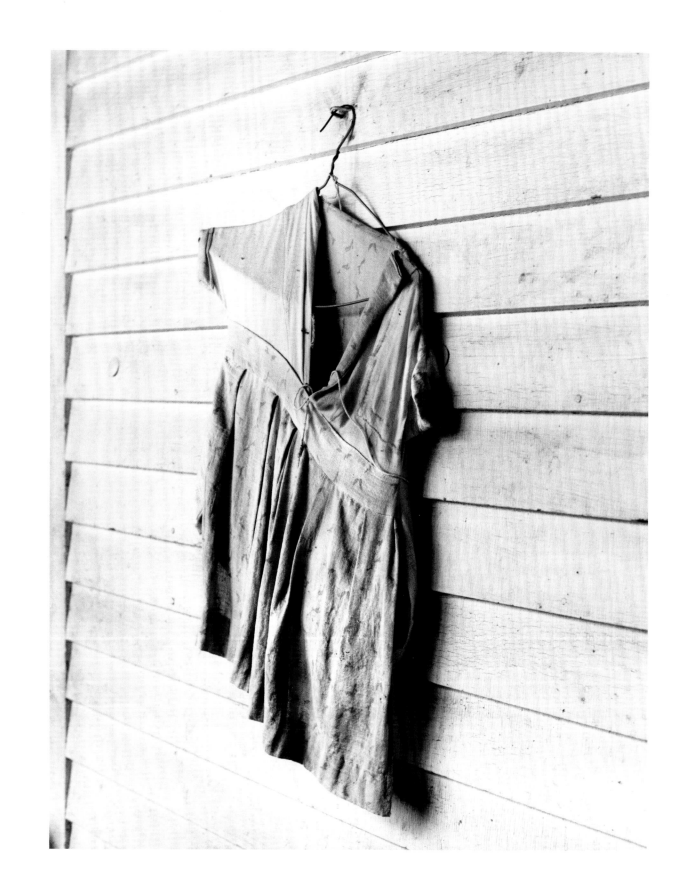

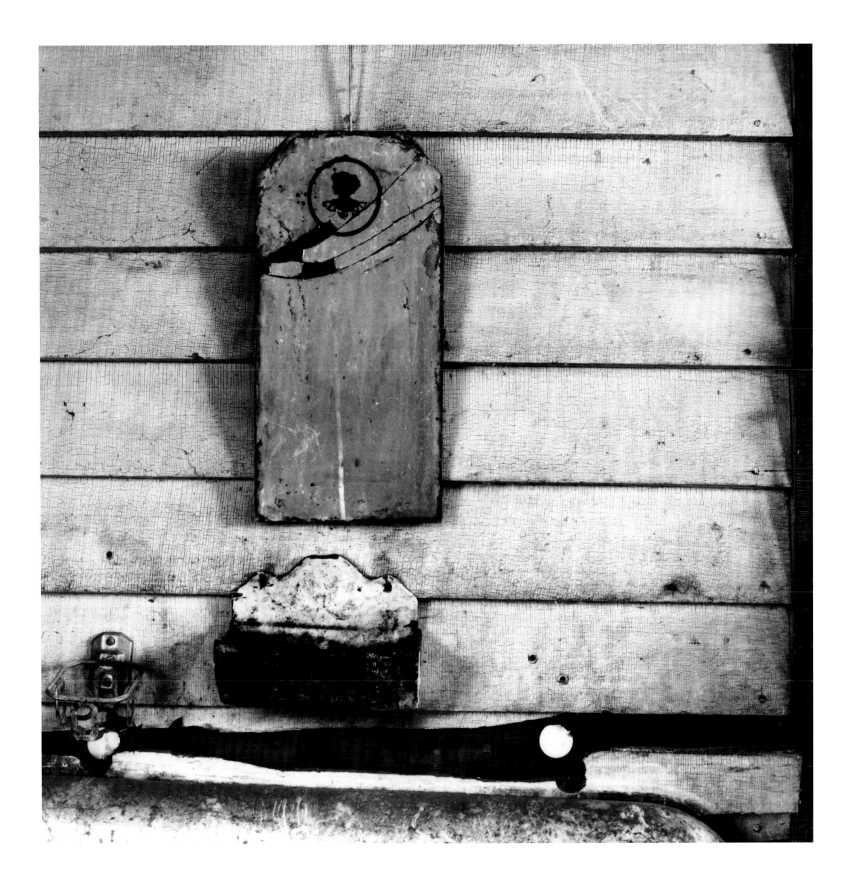

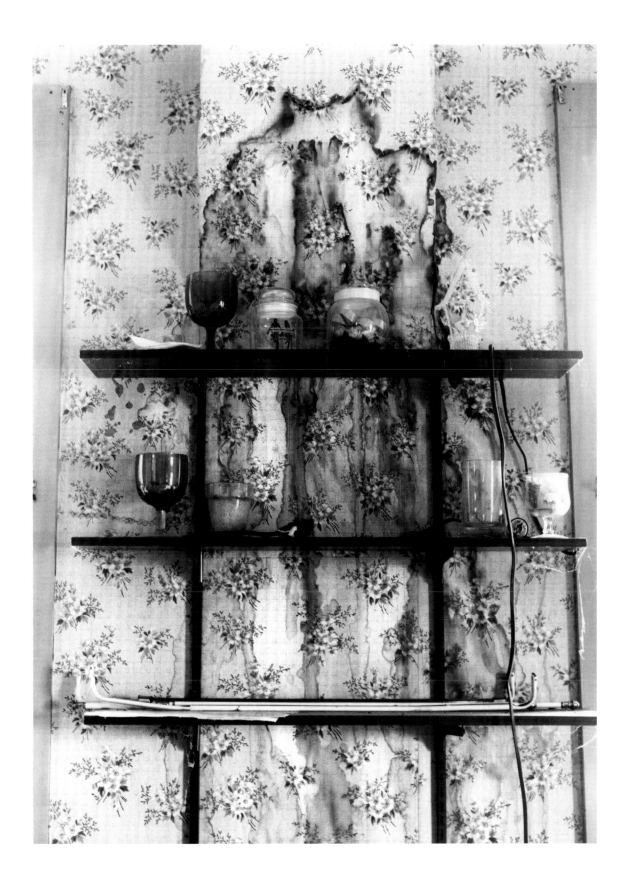

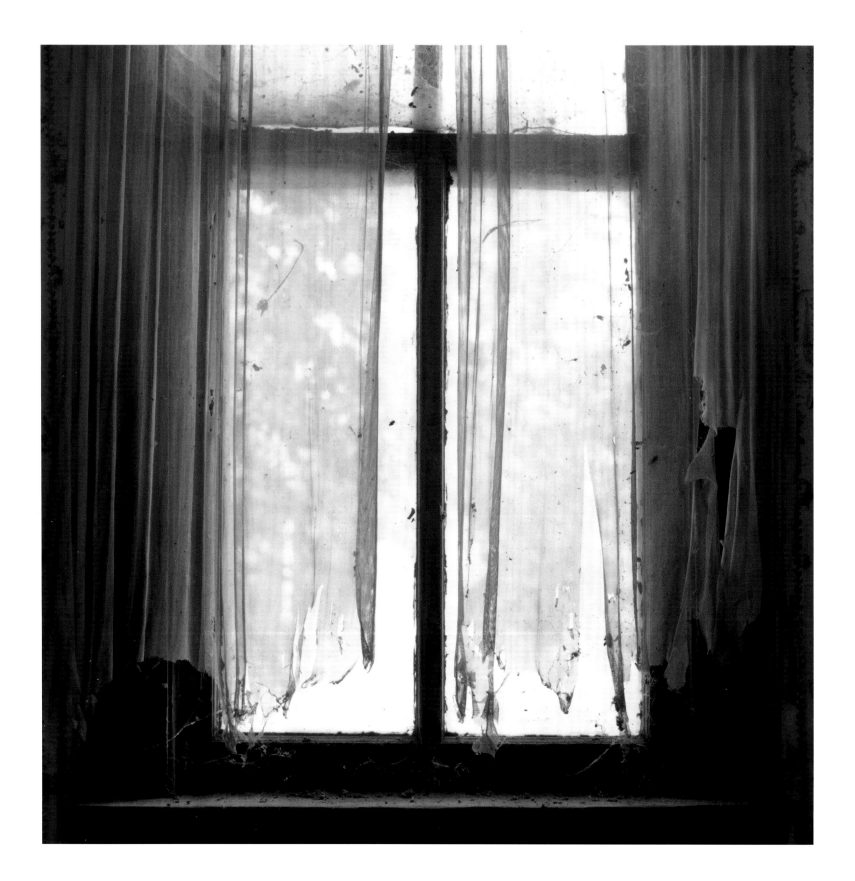

That was good water. Cold water.
I really had the coldest water that
ever was with that cistern.

↔ Ferny

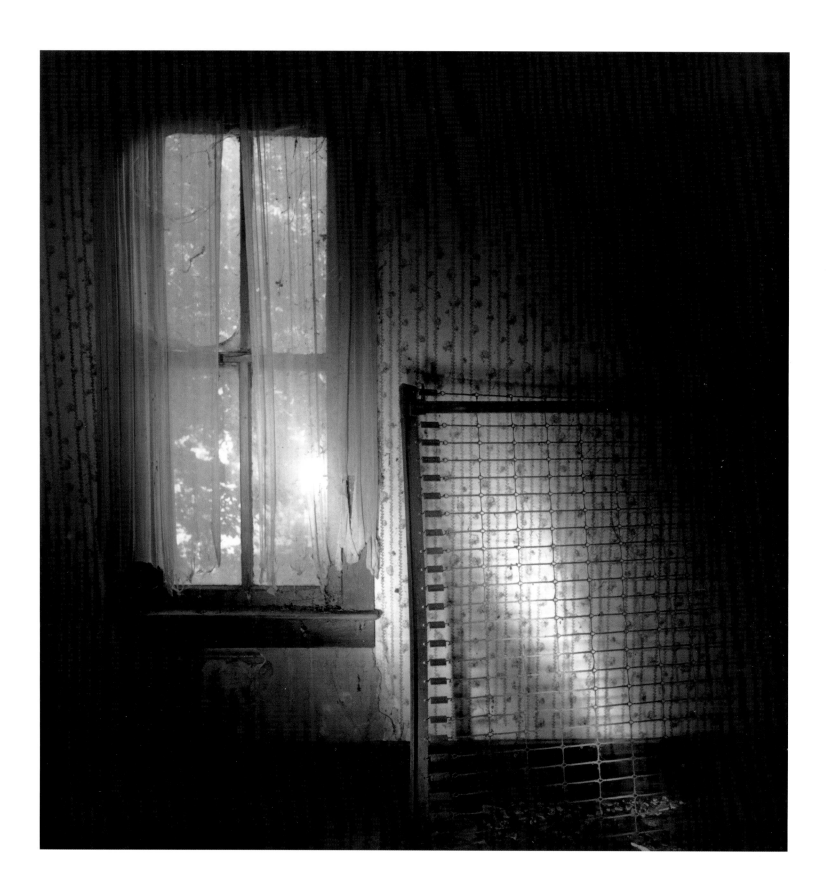

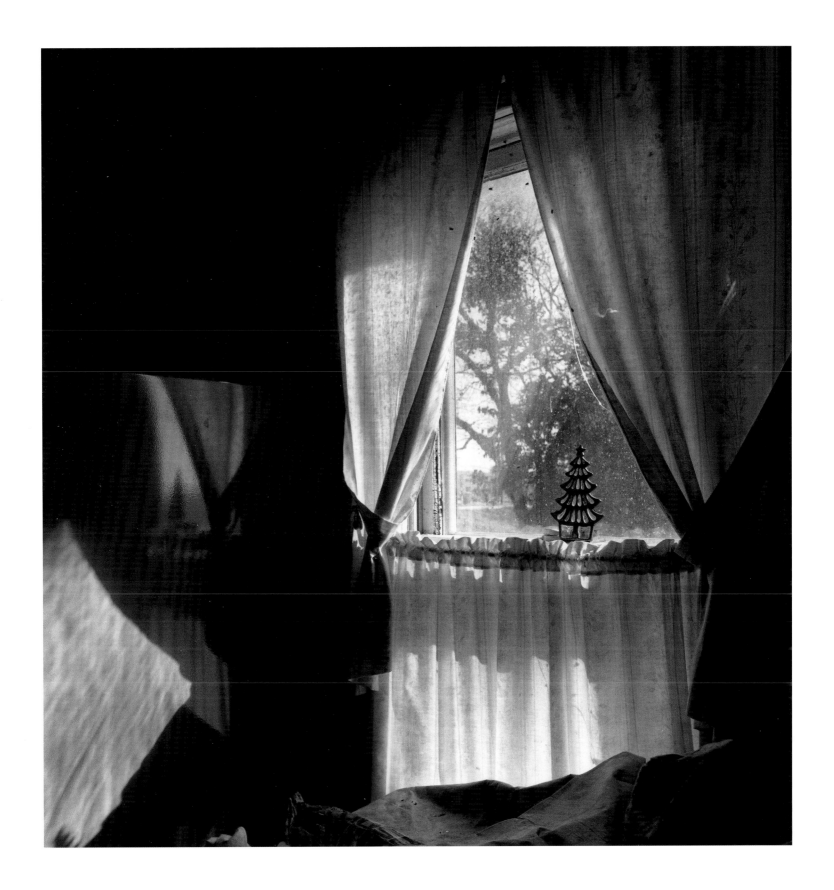

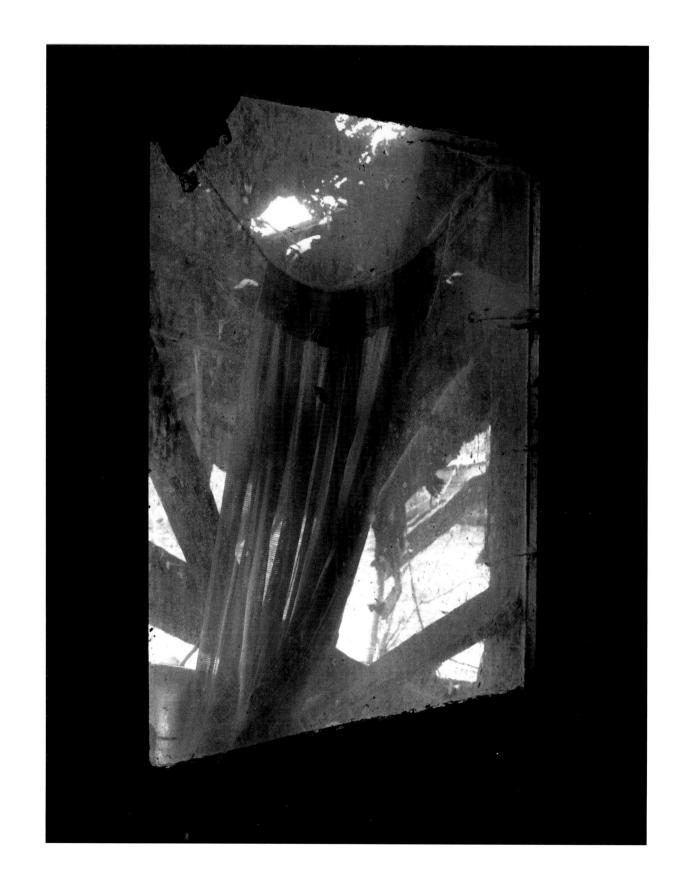

After this hard winter people keep asking me,
am I gonna stay out here. Goodness, how
can you do that? Out there all by yourself!

Sometimes I think about it, and I think maybe
I will. But what will I do in town all day?
I could have coffee all the time. But what about
my animals?

People give me animals they don't want.
Right now I have a parakeet and a fish.
They buy 'em for themselves, but then they
don't like them and they give them to me.

Five of my cats died, 'cause it was such a
hard winter. But there's still seven or eight.
And the three goats.

When it's icy, they told me not to go out to feed
those goats. It was so cold. It was icy. But it
was tempting. To go out to check on my goats.

I was without lights for three days, but I stayed
because of the dog. They said I couldn't take
him with me. But I couldn't leave him alone.

↔ Ferny

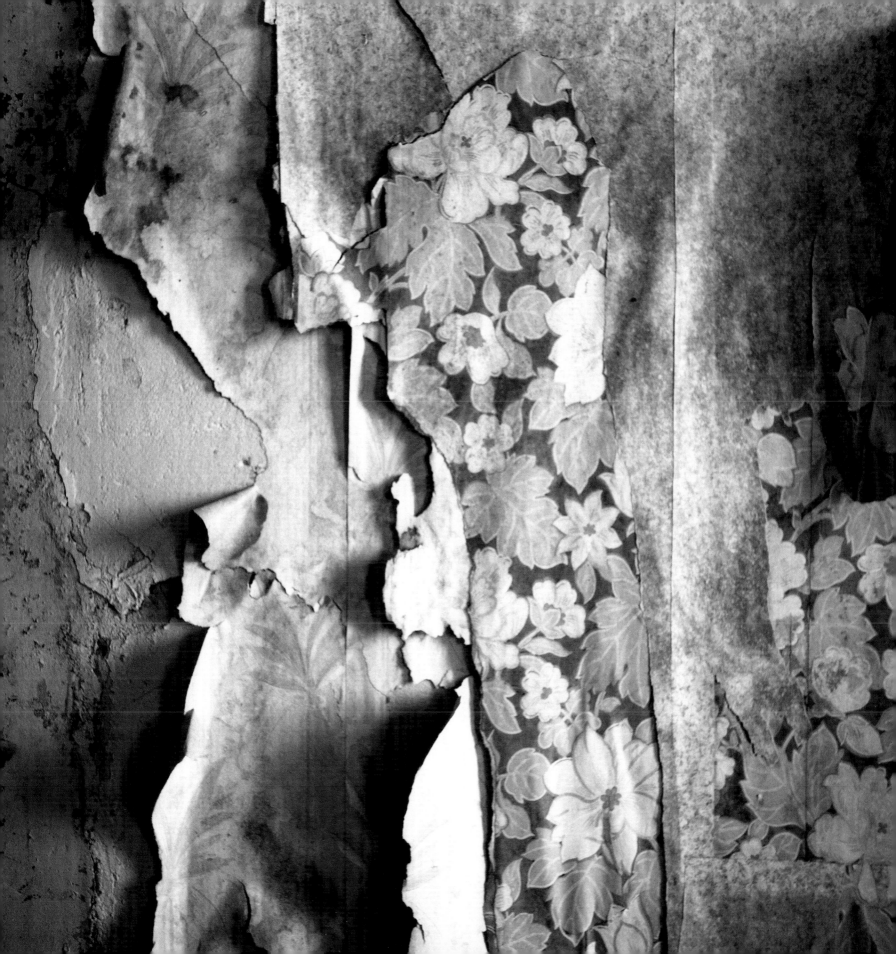

My parents wouldn't let me drive to school,
so I lived in town during the week. They'd
take me into Wisner every Sunday evening.

I stayed with a lady there. She'd make me
breakfast. I don't really remember what I'd
do for lunch.

On Friday afternoon after school my dad
would pick me up and I'd go home for the
weekend and do chores, wash clothes, and all.

When I was a senior, I finally got a Model T.
But they only let me drive on the country
roads. So I had to park that Model T on the
farm of a family friend and walk the rest of
the way into town.

↔ Bonnie

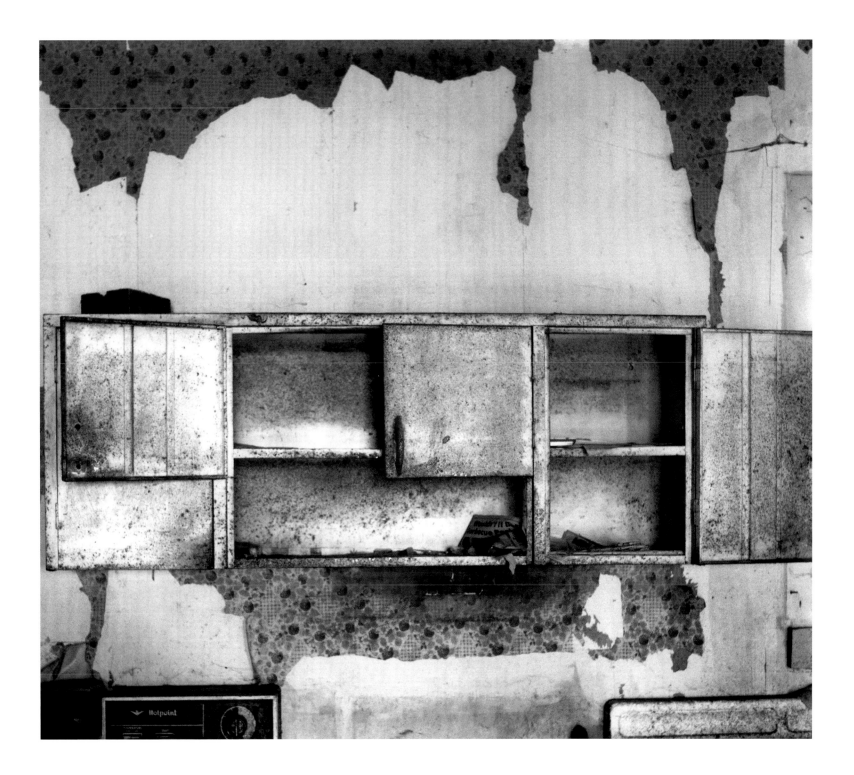

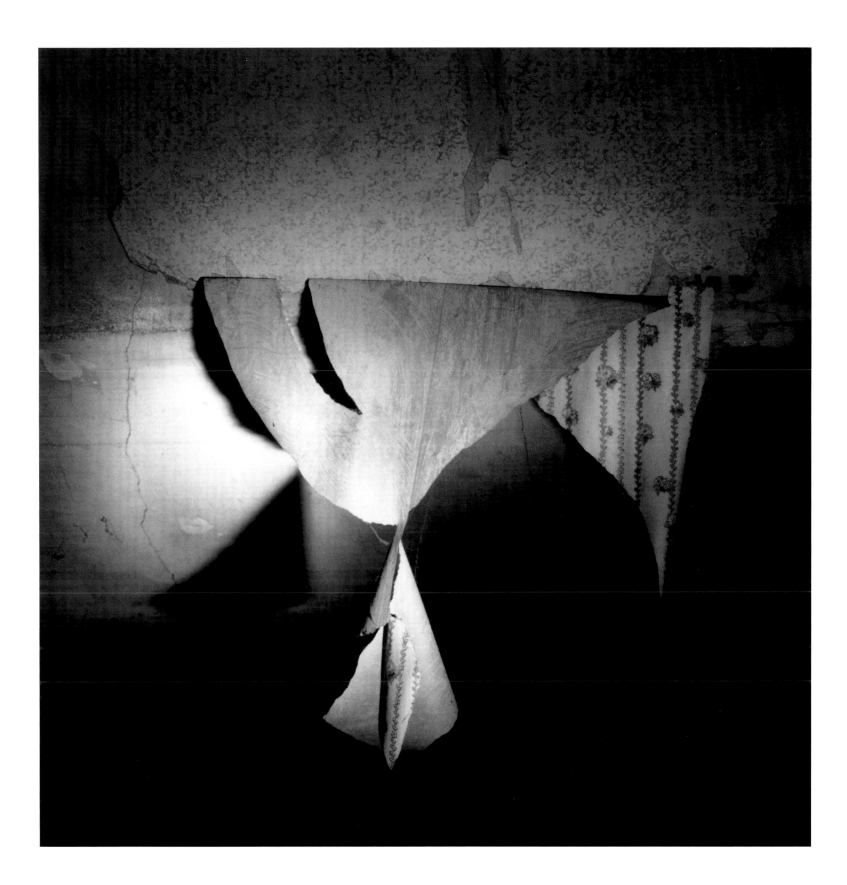

In those first years after Sue and I got married
and started farming this place, there were times
we cried. It was a bad time for lots of people.
It was a real bad time for us, just starting out.
Real bad.

Big debts for equipment, mortgage on the place.
Seed and feed—always bills due. We'd pay one
bill in the morning. In the afternoon, we'd
worry about the ones we hadn't paid.

Nights, we cried.

I talked to my dad. He goes, What have we got
if we quit? Nothing, I said.
What have we got if we don't pack it up? I went,
I said, Maybe something.
He goes, I say we take maybe something. That's
some of the best words that were ever spoken.
That's what we live by here. We gave it a try.

There were some good people: That bill's
been due, and I know that you can't cover it,
but you get me something, whatever you can.
I'm still buying from them, sure and certain,
even if their price is a notch higher.

We made it. It's been an interesting life,
I'll say that. We've been blessed.

↔ Tim

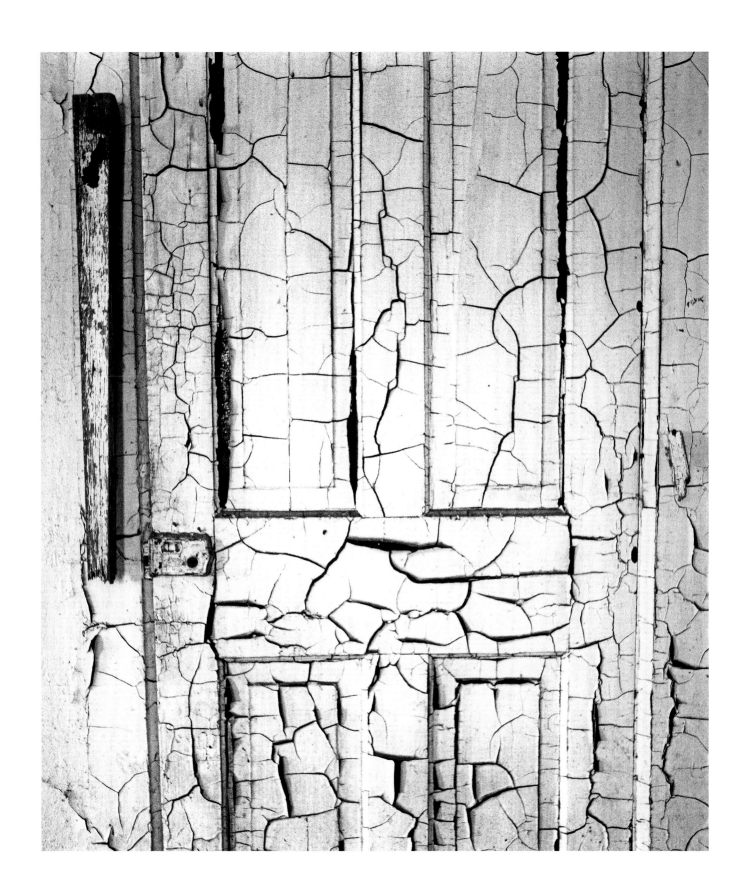

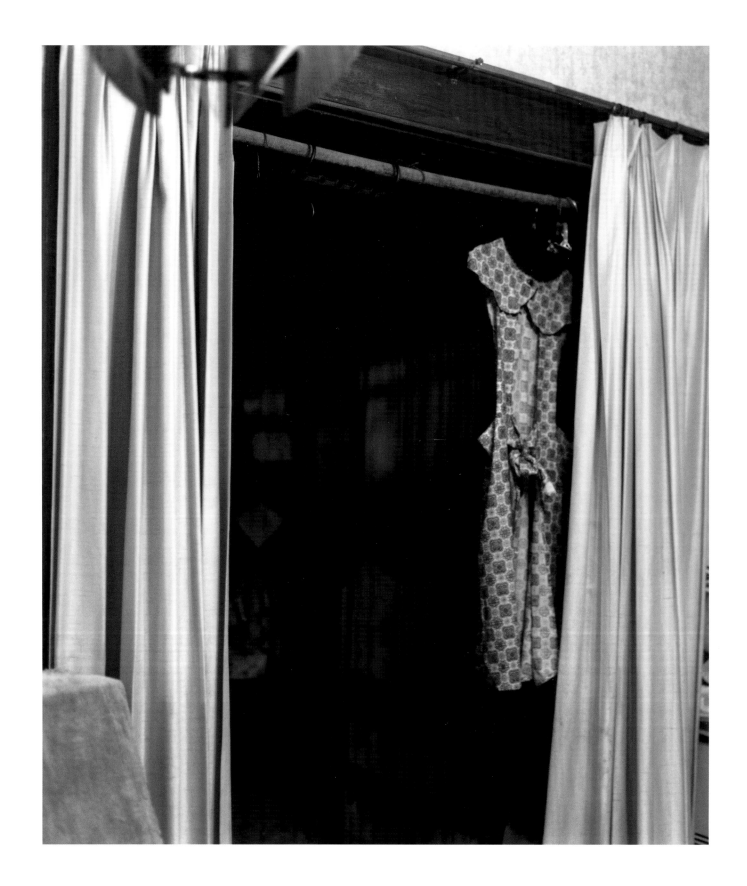

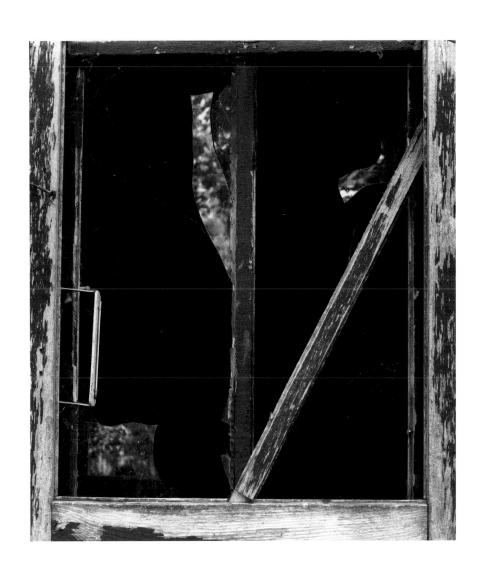

I'm proud to be a farm girl.
I'm proud to have been raised on a farm.
Some people don't think highly of that.
There's a pretty strong negative reaction.
It's a dismissive attitude, that's what I'd say.
It's not hidden, you can feel it.

I work in the capital.

This county, Cuming County, is the number
one corn-producing county in the whole world.
Or maybe it's not exactly number one, but it
must be pretty high.

Where are you from? I go, I was raised
on a farm. They go, Ohhhh, long like that,
and then silence.

It's not all negative. The nice way to put it
would be indifference. I can understand it.
It's far from their experience and they just
can't relate to it.

↔ Katie

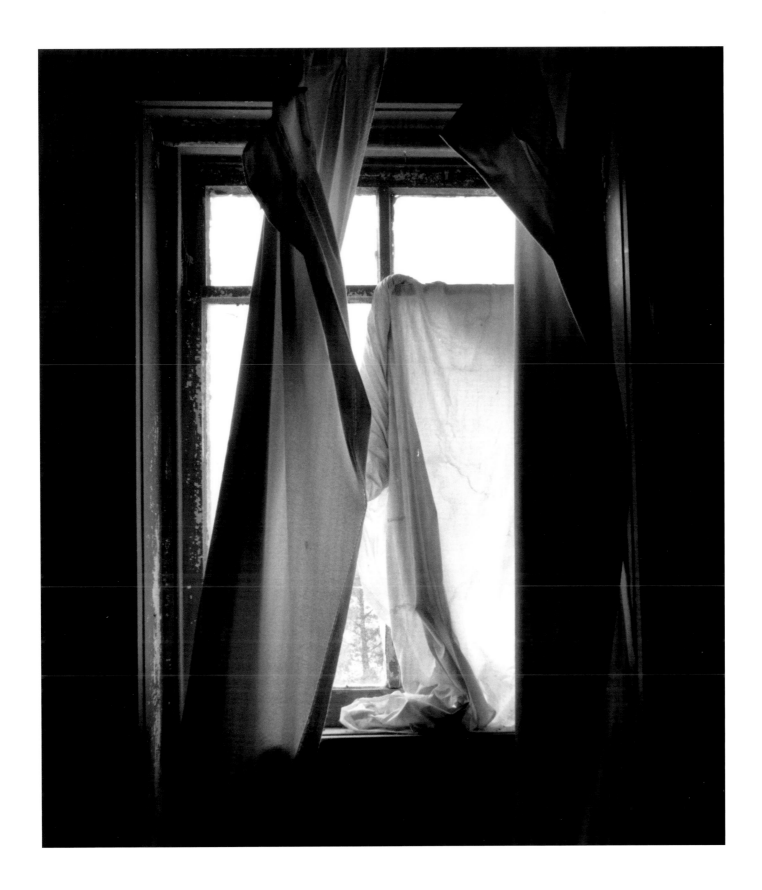

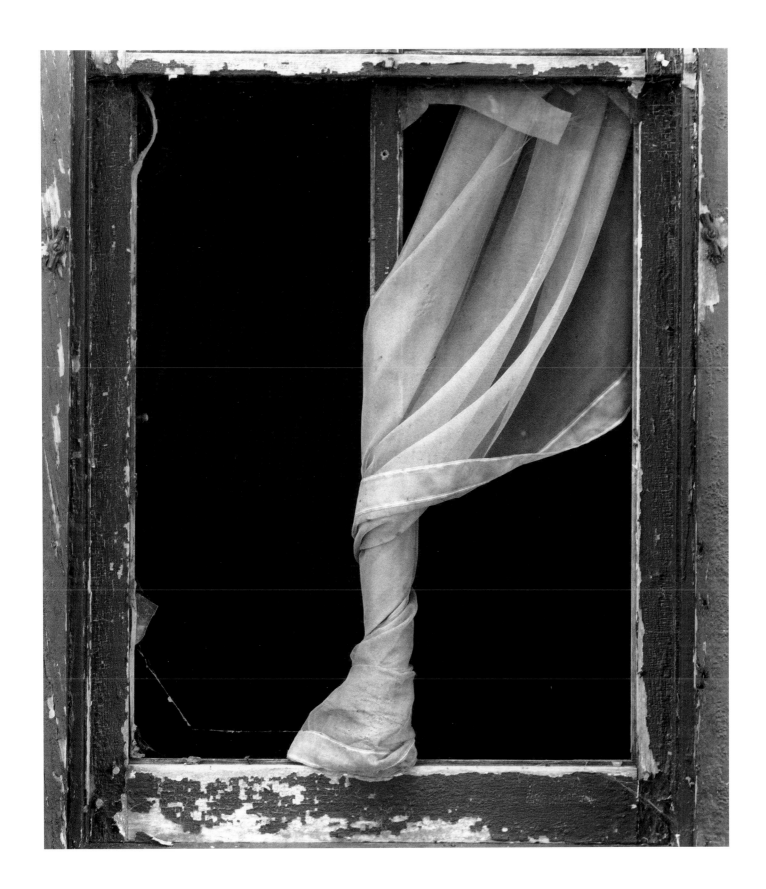

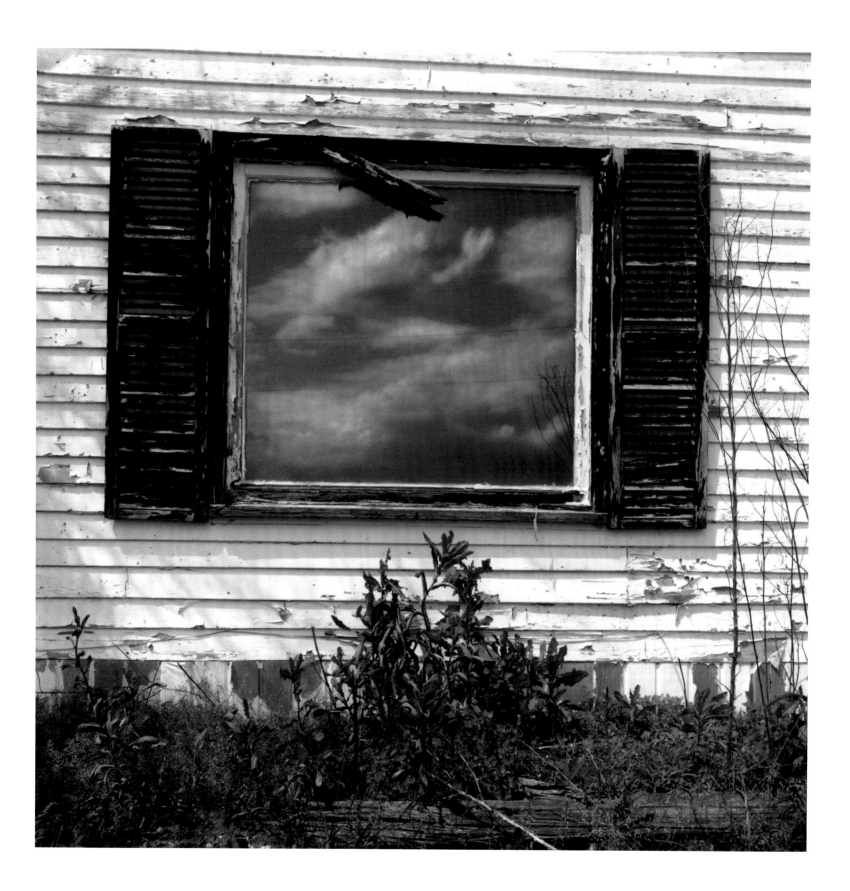

I enjoy planting because it starts the year of farming. I'm prayerful for a chance to see the fruits of my hands.

Hopes are high.

What do I enjoy? I enjoy being out here on my tractor because I like having time with my own thoughts, with this field.

↣ James

But, you know, what I really enjoy is spraying chemicals. That's the best.

I own the sprayer. It's got those big, bouncy wheels and arms reaching out when it sprays.

I go around the field twice. The best part is setting the straight A to B line. Once I've got that fixed, the GPS can show me where to drive.

I'm watching the monitor and everything is clicking right along, whether I speed up or slow down.

I can bounce along as fast as I like. I'm in control.

↔ James

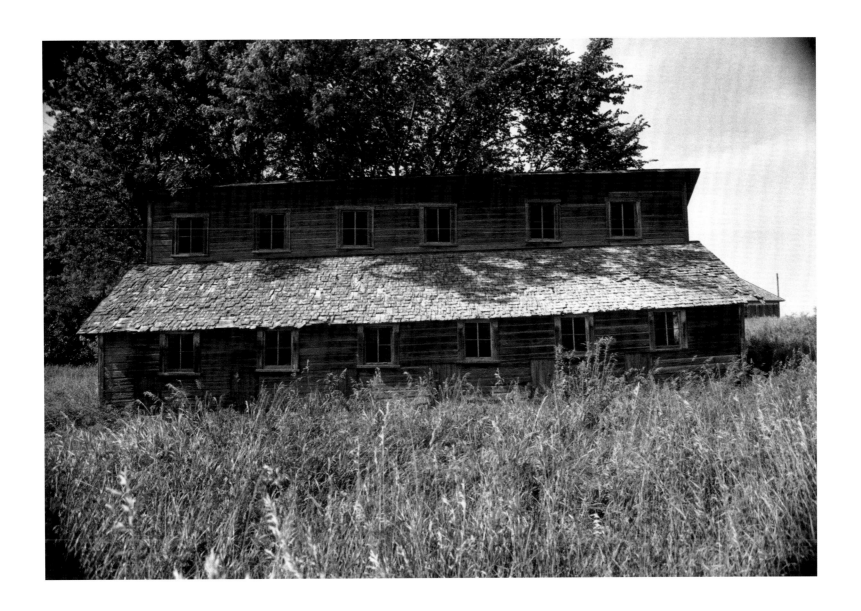

People need to eat. People in Third World countries want to eat better. And this field here is feeding them.

Not everything in our country is going right, but agriculture is strong and it has a future.

If we don't grow it, you can't eat it.

↔ James

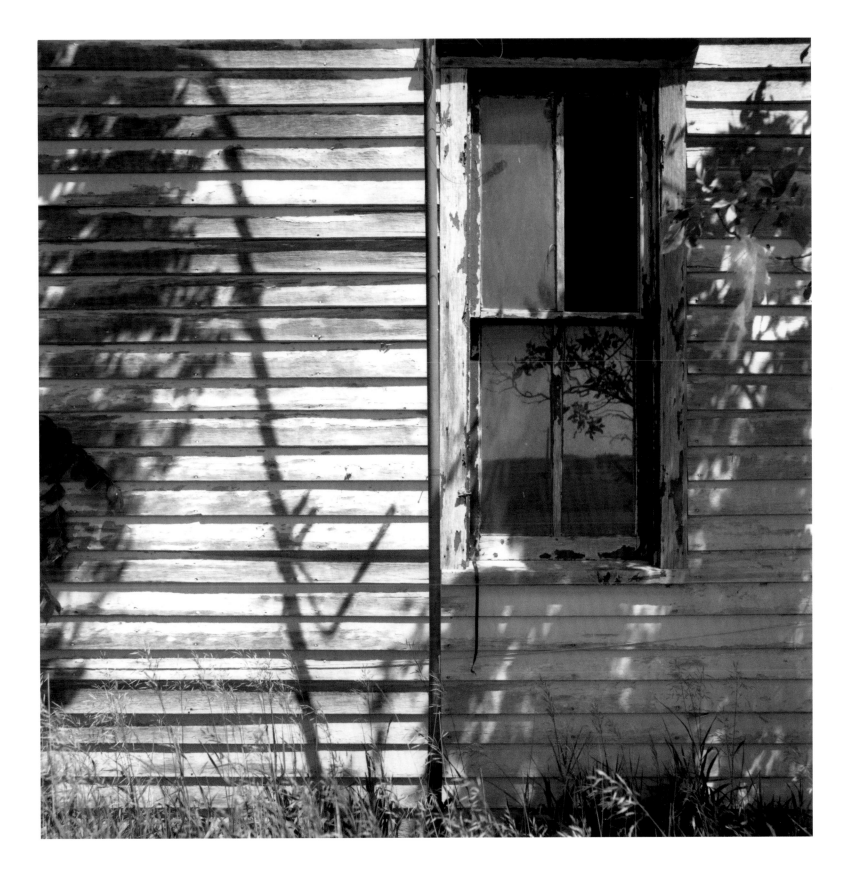

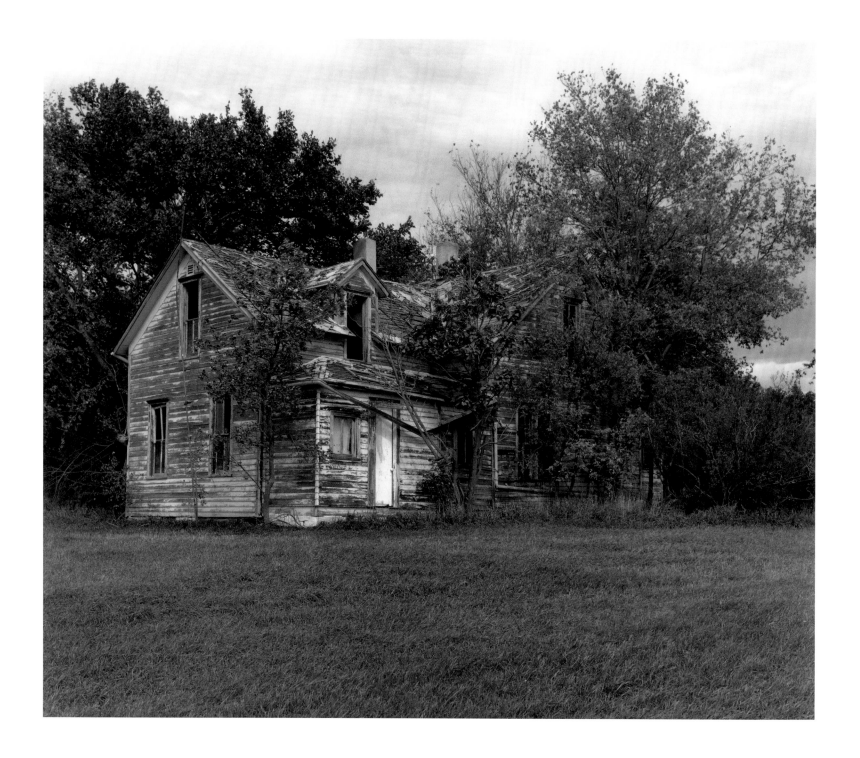

They'll put a match to it and you won't
recognize it. What they do is they take a
bulldozer, knock down the old sheds,
trees too.

If there's a lot of old wood and not too
many trees, it's gonna go pretty easy.
Pour some gasoline on it, throw in
some tires. You're not supposed to
burn tires. Some guys do.

Wait for some foggy morning. Throw in
some tires. Toss on a match. It gets real hot.

Then they'll dig a big hole, bulldoze the ashes
into it, cover it up, and farm right over it.

They're lookin' to use every acre.
Every square foot.

↔ Neil

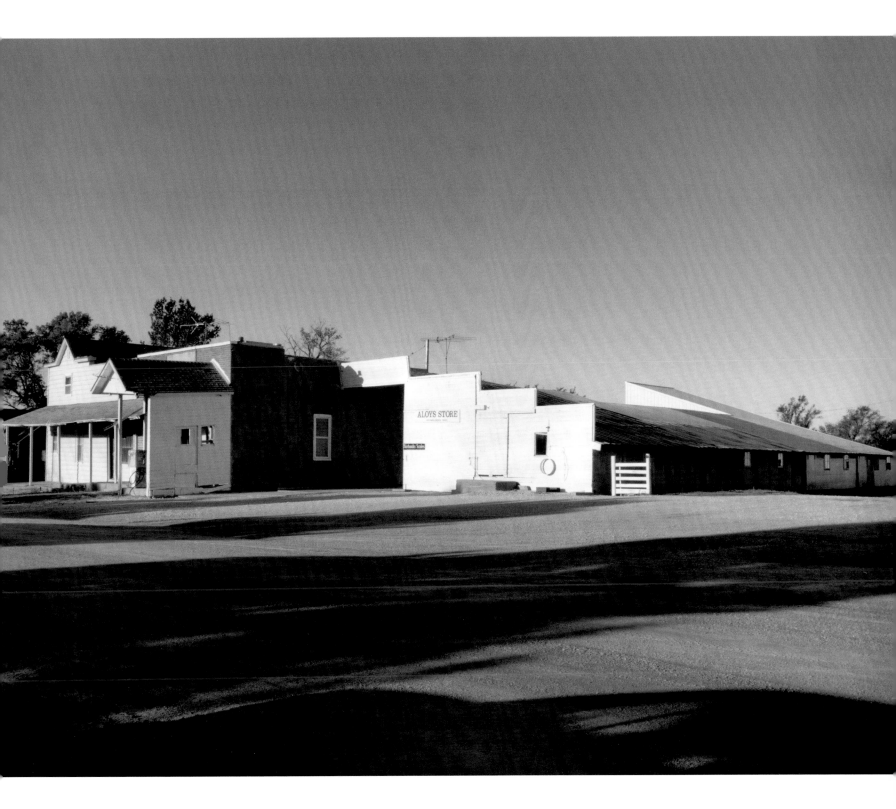

ALOYS STORE AND TRANSFER
ALOYS, NEBRASKA

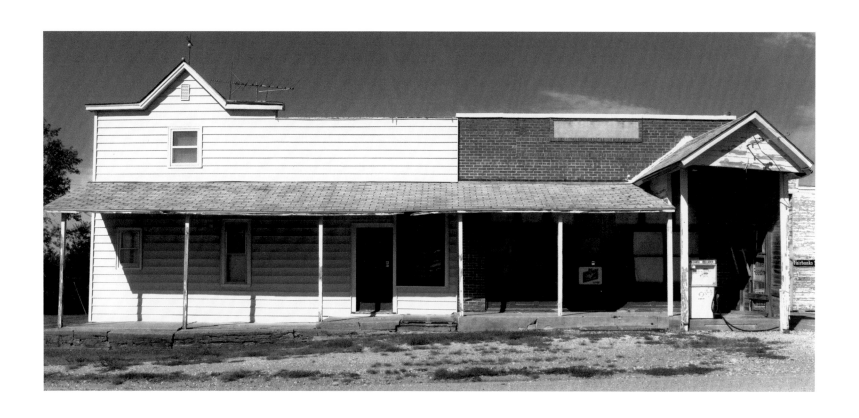

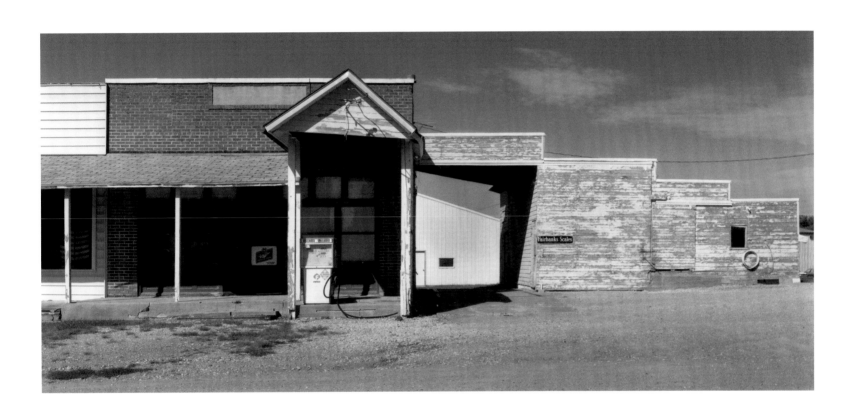

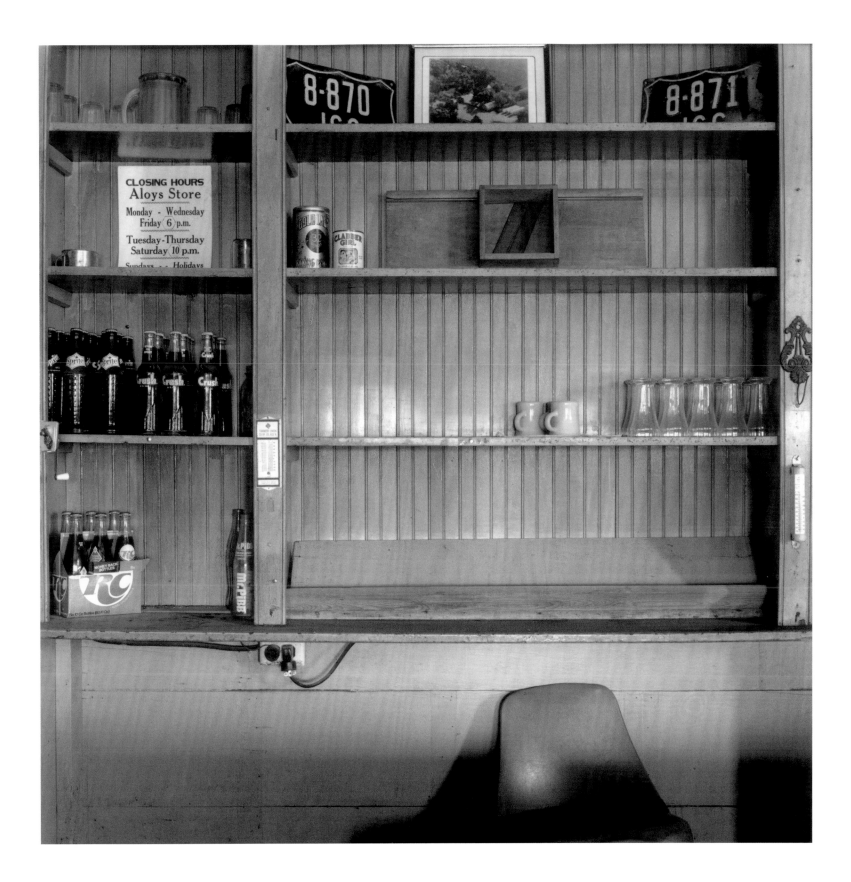

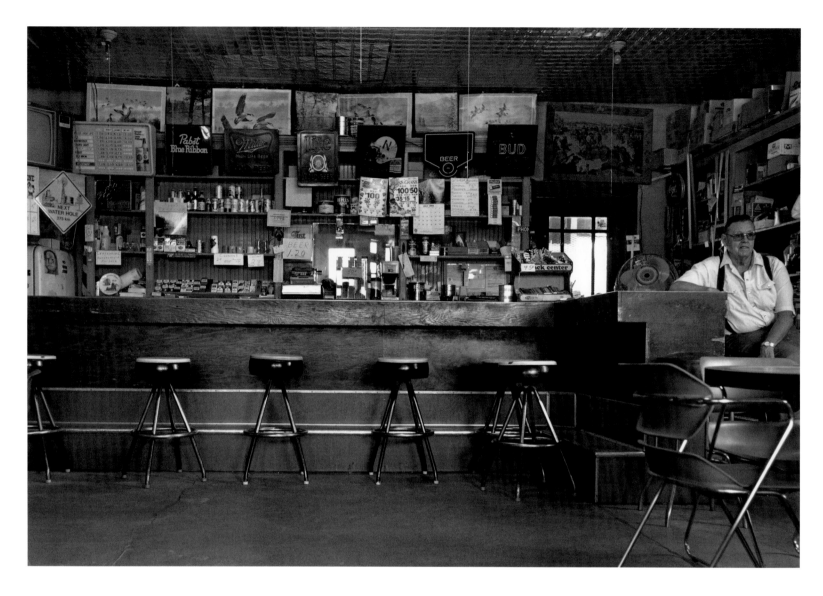

It was someone of my wife's relations who first built it. But my grandfather took it over, must have been before World War I.

After the next war, my father and his brother got into it, keeping the bar and running some trucks as a sideline.

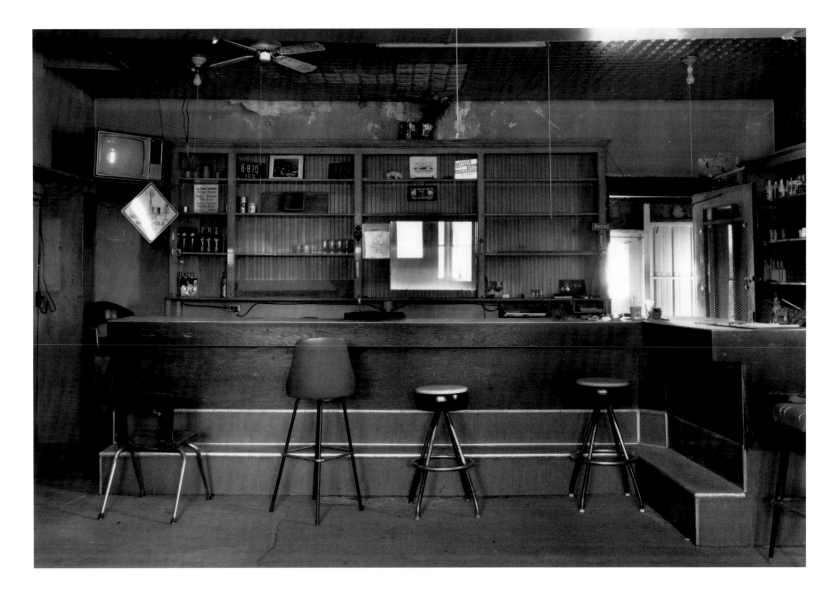

I was working in the bar and on the trucking
side from as long as I can remember,
doing pretty much anything and everything.

In those days, if someone came in for a beer,
it didn't matter if you were just fifteen, you
served 'em a beer.

↔ Bruce

After a while, we saw that the money was in
running trucks. We kept the bar open.
It was fun, but you can't live on that. Finally
we stopped pumping gas. Now we have twelve
trailers hauling cattle.

We tore down the old buildings last year in July.
We put up everything on Craigslist. Folks from
Omaha got some of the stuff.

When we tore up the foundations, we found
old car parts, crankshafts, beer bottles, any kind
of old metal thrown into the concrete.

We don't use it, but we kept the truck scale.
That's a perfectly straight piece of concrete.
No point in destroying that.

↔ Bruce

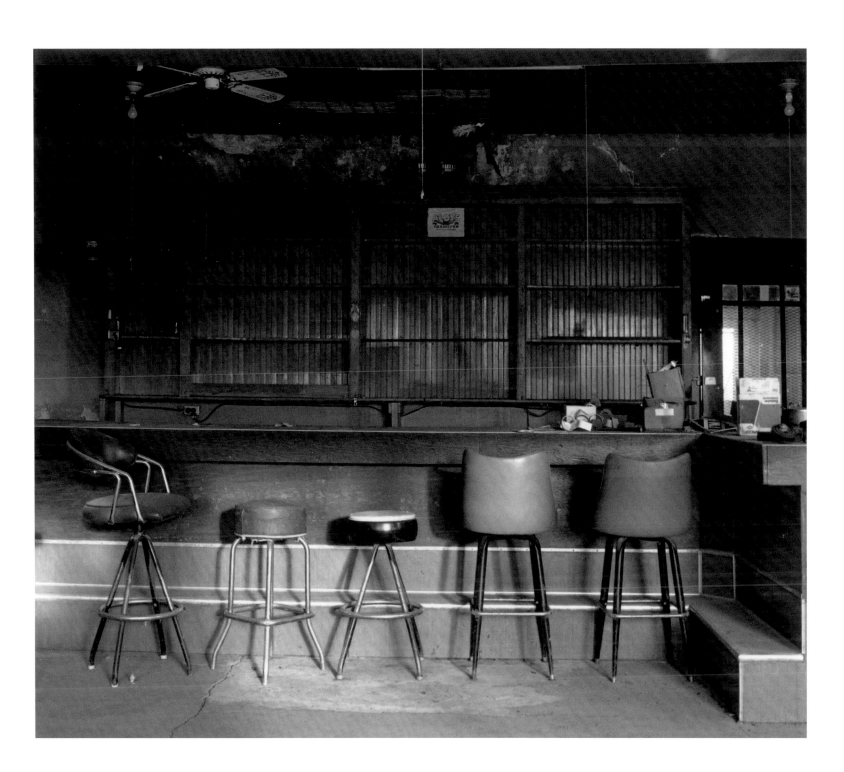

FAMILY ALBUM

That's Norma, and Cathy, and Helen, Ferny, Marlin, Francine.

There's Irma, Aunt Caroline, Reynold, Robert. The little ones
 in the front.

This is a good one. With Dad and that old buggy.

That was fun. These must be snapshots that Talitha took.

This is Aunt Caroline.

Who's that next to Grandpa?

I don't know.

When was this?

That's Dad's writing. First car, 1912.

This must be Willard, and that must be Charles.

You probably saw that one before.

Norma and Eileen were in that wedding.

Who are these two?

I like that picture.

Dad never told me you had a pony. Did you all have a pony?

Ummm, no. There's Opal, that's Willard, Marvin Ott,
 and that's me, the baby.

I didn't know you had a pony.

Well, I was the baby.

Mom and me. I don't know who's all on it.

On this one you can see it a little better.

Oh, aren't these awful. Turn fast.

I'm surprised that these weren't in Mom's box in town.

That is a good picture.

Did you know that Scott had a stroke?

When did that happen? I was so shocked.

Look at all the chairs piled up. You know who
 the bartenders were.

Look how thin you were.

This is Aunt Ivie. I can't see too well.

Must have been a wedding.

My two dogs. My wonderful dogs.

She's pretty. Isn't that Dorothy?

Were you her sponsor?

No, that was Irma.

Kathy looks like you in that picture.

Charles, Orville.

Me in a scarf.

You must have had your hair in curlers.

Yeah.

They've always got their arms around
 each other.

So in love. Still in love.

Whose place was this then?

At their 40th anniversary.

I wish I had kept that doll.

I can still remember that license plate number, 717.

That's you and Shim.

That is a good picture.

That's me fishing in a dress.

Charles looks sick in this.

But we didn't know it then.

Only Mom did.

That's a good picture.

I love that picture.

↔ Ferny, Opal, and Nancy

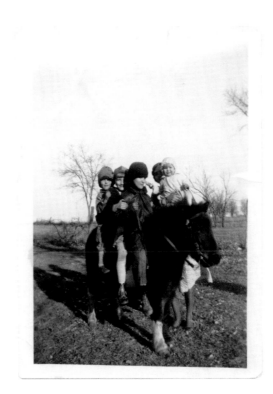

THERE'S OPAL, THAT'S WILLARD,
MARVIN OTT, AND THAT'S ME,
THE BABY. CIRCA 1930

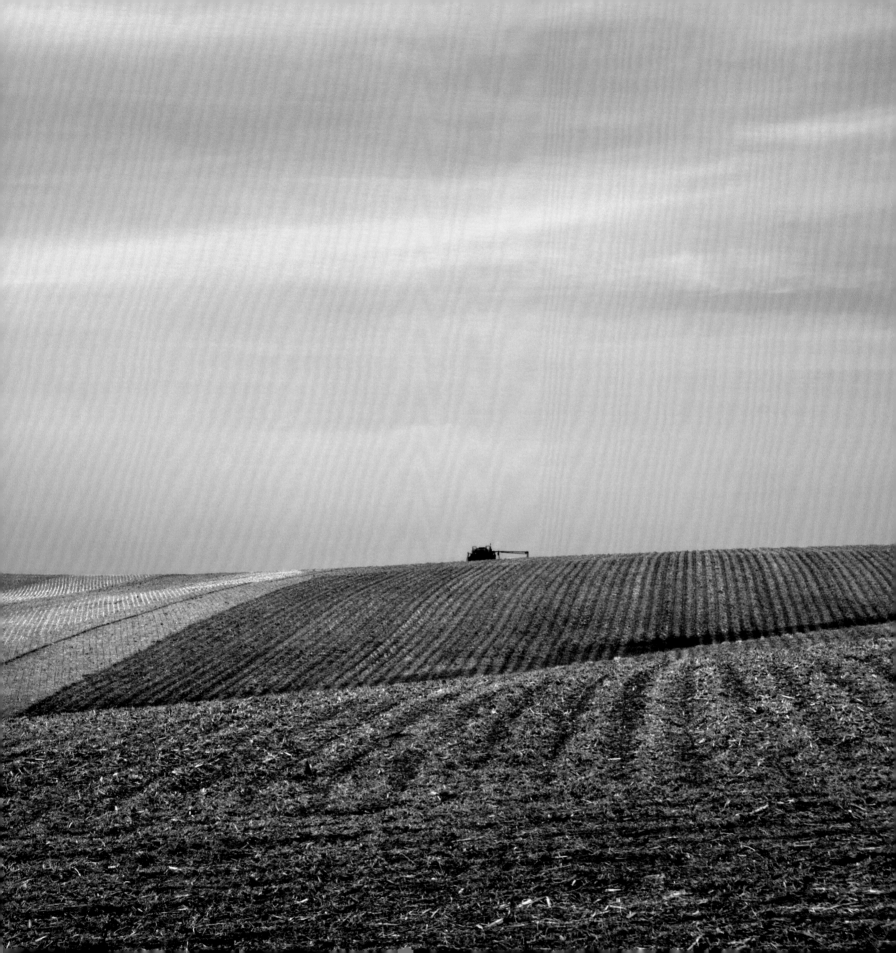

AFTERWORD

LIFE AND SHADOW ON THE GREAT PLAINS

DAVID STARK

THE PLACES

To the city dweller, there's something curious in the language of Great Plains farmers: they almost never refer to *farms*. Instead, they refer to *places*: "the Stark place," "the Ott place," or "the old Feyerherm place." A place is a farm; but it is more than that, for it is inhabited. It has fields, but it also has buildings, barns, a house, corncribs, farm animals, dogs, and people. Crops are grown and animals are raised on farms. But a farm place is more than a setting for agricultural activity. Curtains are mended, windows are repaired, kids are diapered, and families are raised. That's what it means to be a place.

Many Americans have never seen a farm place on the Great Plains. But if you have never been on one, close up, firsthand, it's likely nonetheless that you've seen signs of them from your airplane window while flying over the plains. As you look down from 30,000 feet, you see the giant checkerboard formed by the remarkable regularity of country roads crossing at one-mile intervals. Each of these squares is called a *section*.

If you flew over Nebraska in the middle of the twentieth century, you would typically have seen signs of four farm places within each section. That is, whereas the squares were broken up by the patterns of fields—some brown after plowing; others green, awaiting the harvest—you would also have seen, even from a great distance, the signs of clumps of buildings, a drive reaching from the country road to them, and trees (just to the north of the house and barns, as windbreaks to give some shelter against the cold gusts sweeping down from Canada). Four places to each square section. One to each *quarter section*.

This square-mile and quarter-section pattern was a legacy of the settlement of the Great Plains a century earlier. The mile roads originated in the policies that gave us transcontinental railroads. As an incentive to span the continent, the railroad companies were given every other square mile of land on each side of the newly laid tracks (with each square mile in between going to fund the land grant college system). The four farm places per section came out of the Homestead Act, signed by President Lincoln on May 20, 1862, at the height of the Civil War. Anyone who had never taken up arms against the U.S. government could file a claim for a federal land grant. To gain full legal title to that land, the homesteader needed to be at least 21 years of age, live on the land for five years, and show evidence of having made improvements.

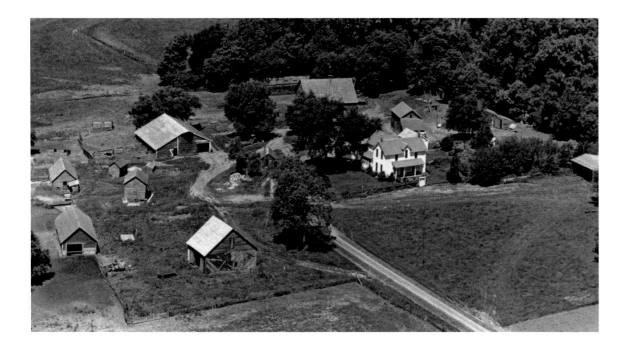

A homestead was limited to 160 acres—exactly one quarter of a square mile.

Life was difficult for these homesteaders. Not a few were unaccustomed to farming. They and others frequently lost their farms to bank foreclosures. But many survived the physical rigors and economic hardships of life on the Great Plains. And others moved in to try their hand at raising crops and livestock on some of the most fertile soil in the world. The consequence, at least in eastern Nebraska, was that the pattern of an average of four farm places per section survived for over a hundred years.

In the sixty years since mid-century, that pattern has changed. The next time you fly over the plains, look down, and you will see fewer than two farm places per square mile. On many sections you will see only one, and on some sections you will see none at all. The farm places—those clumps of buildings, driveways, and trees—are disappearing.

It's not that agriculture is in decline. In fact, more and more of the land is being farmed. But less and less of it is on places.

The photographs in this book commemorate those disappearing places. The voices in this book belong to farmers and their families who once lived or still remain on those places that survive.

The photographer, Nancy Warner, lives in San Francisco, where she has a studio on a narrow street in Chinatown. I live in Manhattan, where I teach at Columbia University. We are city dwellers. And we are products of a Nebraska farm place. My father, Willard, and Nancy's mother, Opal, were born and raised on the Henry Stark place, homesteaded by our great-grandfather, August Stark, in 1865.

By 1950, around the time we were born, there were about 110,000 farms in Nebraska, their average size a little more than 400 acres. By 2007, the average size of a Nebraska farm had grown to

almost 1,000 acres. But there were fewer than 50,000 farms.

This historical process is explained, in part, by the lure of the city. Beginning with World War II, young people were pulled from rural areas, leaving a population with an increasingly aging demography. But the dwindling numbers of farms and their increasing size were also shaped by factors economic and technological. The mechanization of agriculture meant that more land could be farmed with fewer laborers. And the high prices of this equipment meant that its purchase was viable only for farmers with larger acreage.

The push toward ever larger fields has been accelerated by technological developments. First, genetics and the chemical industry have combined to produce new disease-resistant seeds that nonetheless seem to require ever larger quantities of fertilizers and insecticides. Carpet bombing the soil to kill everything except the seed and the plant itself means that farmers can adopt no- or low-tillage practices, since there are virtually no weeds to plow. Keeping the silage as ground cover mitigates soil erosion but also reduces the value of trees and hedges as windbreaks.

Second, biochemistry is developing more and more novel uses for field corn. Once only fed to cattle, it is now ubiquitous in our diet in the form of corn syrup. And we feed it, as ethanol, to our cars, trucks, and SUVs. As an early example of a nonfood use of corn, ethanol is a likely forerunner of many novel products derived from the maize once grown by Native Americans. These developments have already stimulated an increasing demand for agricultural commodities. In recent years, the resulting high prices for corn and grain have further intensified the drive to bring every available square foot of soil under cultivation.

The third technological change can be described, with some exaggeration, as the "roboticization" of agriculture. Drive down a typical Nebraska country road and you may see coming over the low rise of a gently rolling hill a 32-row planter, crawling across the landscape like a giant mechanized insect. Or turn to the other side. There's a chemical sprayer, trailing dust while racing at breakneck speed, its arms extended like the wings of some dragonfly ready for flight.

In the not so distant past, seed corn was dispersed by a 4-row planter. Today, a 12-row or 18-row planter is on the smaller side—for there are 24-row, 32-row, and 36-row planters. In one pass, the even more gargantuan 48-row planter can cover 120 feet—more than a third the length of a football field.

These high-tech planters have onboard computers with GPS guidance systems. An equipment operator will manually guide a planter around the perimeter of a field. When the planter reaches the starting point, as one of my cousins explained, "The computer beeps, you flip a switch, take your hands off the steering wheel, and it runs itself." A planter on autopilot can plant seeds on the "A to B straight line" with remarkable precision. With a tolerance of only an inch or so, there are no gaps or overlaps between one passage of the field and the next. Because no further guidance is needed, the equipment operator can use the onboard computer to check on market prices, look for options on grain futures, buy shares of meat-packing firms (as a hedge on falling cattle prices), or just surf the web and play video games.

Some months later, the same onboard computer, linked to a GPS, will record harvest yields on a square meter by square meter basis. By programming the planter or the fertilizer application to

data collected by the harvester, more or less seed or more or less fertilizer will be applied, depending on soil conditions, hilly terrain, and so on.

Seed is a science. Farmers in eastern Nebraska have hundreds of varieties of seed corn to choose from, with various combinations of time until maturity (100 days, 105 days, 110 days) and hybridity (more or less drought tolerant, adjusted to salinity or other soil conditions, and resistant to this or that insect or disease). Specialized vacuum equipment, carefully calibrated to shoot only one seed at a time, dispenses the seed at precise intervals.

Modern irrigation systems are sometimes GPS guided or, more frequently, use electronic tracking devices buried in the earth. The long boom arms of a pivot irrigator can swing out and then retract to catch the corners of a field. The 450-horsepower diesel engines (like the motor of a semi trailer) pump water at 3,000 gallons a minute.

Such equipment is not acquired on the cheap. A new John Deere sprayer, for example, will set you back $280,000.

These economies of scale, scope, and technology sweep away the fences that once separated fields. The fields grow larger while the old farmhouses, adjacent outbuildings, and groves of trees that once harbored rabbits, foxes, and pheasants dwindle. Farm prices rise, but farm places are disappearing.

THE PEOPLE

Cuming County, Nebraska, was settled by Central European immigrants. Like today's immigrants, who reinvigorate our country with their energy, hard work, and ambition, these settlers came to the United States looking to make a better life.

Our great-great grandfather, Wilhelm Stark, and his wife, Sophia, were among these immigrants. They left Prussia on the passenger ship *Perseverance* in the spring of 1852 and arrived in New York City, en route to Wisconsin, on June 10. Their six children, ranging from two to ten years old, accompanied them.

This was in the days before steamships, and the sailing vessels took at least forty days, often much longer, to cross the Atlantic. It was only after finding the official New York City passenger list through an online search that I learned that a seventh child, a baby boy, had been born on board and died eight days later while still on the voyage.

Wilhelm and Sophia's oldest son, August, spent his adolescent years in Wisconsin. In 1863, he left for Nebraska. There he homesteaded a farm in Cuming County, the first homestead in Elkhorn Township, in 1865. Various early records show his birth date as November 1845. But records later in the century put it as 1844. One needed to be twenty-one years of age to be a homesteader, so it's quite likely that August adjusted his birth date to be in compliance.

Trees were scarce on the prairie and milled lumber even scarcer, so August, like many pioneers, made his first home out of sod. With a straight shovel he cut the sod—two shovel lengths for the longer sides, one each for the shorter sides. These could be stacked like bricks to build a structure like the one in Solomon Butcher's photograph of the Sylvester Rawding family. The prairie grass held the dirt together for at least a couple of years. Later August ordered some pine lumber from Omaha and built a simple structure that served first as a home and later as a corncrib.

On February 23, 1871, August married Carolina Brockman, who, like him, had come from

	Names	Age	Sex	Occupation	Country to which they severally belong	Country of which they intend to become inhabitants	Died on the Voyage
86	August Schley	20	Male	Farmer	Prussia	Wisconsin	
87	Julius Schley	19	Do	Do	Do	Do	
88	William Stark	44	Do	Tailor	Do	Do	
89	Sophia Stark	34	Female	—	Do	Do	
90	Augustine Stark	10	Do	—	Do	Do	
91	Wilhelmine Stark	9	Do	—	Do	Do	
92	August Stark	7	Male	—	Do	Do	
93	William Stark	6	Do	—	Do	Do	
94	Anna Stark	4	Female	—	Do	Do	
95	Carl Stark	2	Male	—	Do	Do	
96	Ocean Stark	8 days	Do	—	Do	Do	Born by 8th Died 16th
97	Joachim Degner	67	Male	Farmer	Do	Do	
98	Dorothy Degner	50	Female	—	Do	Do	
99	Rosina Degner	16	Do	—	Do	Do	
100	Anna Degner	14	Do	—	Do	Do	
101	William Degner	8	Male	—	Do	Do	
102	Frederick Jäger	28	Do	Mason	Do	Do	
103	Harrold Halverson	35	Do	Cooper	Denmark	New York	
104	Carl Humble	26	Male	Mariner	Do	Do	
105	Christian Humble	24	Male	Do	Do	Do	
106	John Bay	23	Do	Farmer	Germany	Wisconsin	
107	Christian Rober	33	Do	Mason	Germany	Illinois	
	One Child born few days ago						

Germany with her parents, in 1854; first settled in Wisconsin; and then moved on to Nebraska. Carolina was fifteen at the time of their wedding. She and August would have thirteen children, seven of whom survived infancy.

The railroad arrived in nearby West Point, the county capital, on November 25, 1870, bringing with it a flood of new settlers. Homesteading was booming so much that the Nebraska land registry office was relocated from Omaha to West Point. By 1900, the population of Cuming County reached its historical high of 14,584. But the defining event of the epoch was on November 9, 1933, when an estimated 75,000 people came to the Ben Stalp place, just north of West Point, to attend the National Cornpicking Contest.

By 2010, there were fewer than 10,000 people living in Cuming County.

These people do not appear in Nancy's photographs. Instead, they are present here in their *voices*. Just as the photographs capture the stark reality of their artifacts, so the text that accompanies the images captures the spare vernacular of their voices. I have reported them just as I heard them.

To someone coming from Manhattan or San Francisco, there is something immediately strange and then later richly appealing in the speech of central plains farmers. To say that their voices are laconic would not do justice to the silences. Like many Midwesterners, they prefer to listen and to wait. Put several of them together and, given this disposition, there will be long moments of silence. To outsiders, that silence might seem fraught with tension. So unaccustomed to, even intolerant of, the shortest break in conversation, we city folk tolerate interruption as an acceptable pattern of communication. Our Nebraska friends and rela-

tives, we learned, are comfortable with silence.

When they do speak, it is with an almost deliberate understatement. You'll encounter the sign language variant of this brevity in the understated gesture of greeting as you pass a car or truck on a country road. The gesture of acknowledgment, whether you are friend or stranger, is not a broad wave, not even a hand of fully extended fingers. Simply, the index finger lifts off the steering wheel, is raised for just a moment, and then returns to the grip.

The speech of these farmers is also markedly literal. They seldom use metaphors. That literal speech was particularly striking to me as someone who grew up in Oklahoma, where to be expressive means to speak with metaphor, simile, and other rhetorical tropes. My dear friend in Oklahoma City, Leonore Sells, could never simply tell me that someone had related a sad story. Instead she'd say, "David, she just reached right in, took my heart, turned it around, and put it back again."

One is unlikely to encounter such dramatic flair in the statements of a northern plains farmer or cattleman. They can, however, tell a good story. But if you look for a single metaphor among the voices in this book, you will search in vain. For the men and women who farm the plains, things are not like something else; they are what they are. As with the sparseness of the landscape and the austerity of these photographs, their expressive voices are powerful precisely because of their direct and literal style.

In their personal conversations, moreover, the farm people of Kansas, Nebraska, Iowa, and the Dakotas are reticent in praise. It would be simply unacceptable for a parent to boast effusively of a child's accomplishments, and it would be almost

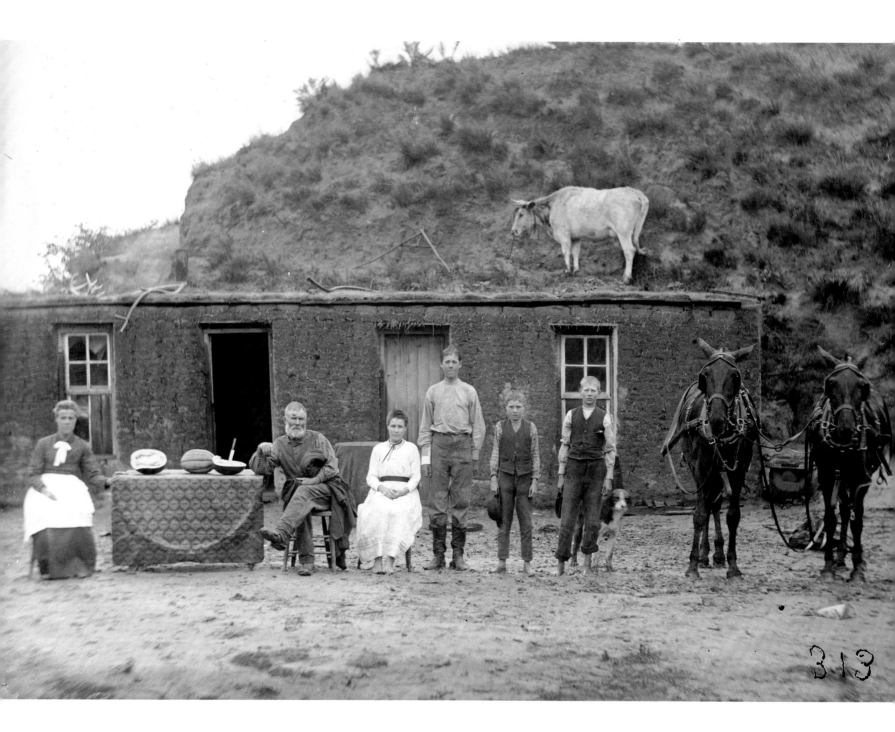

SYLVESTER RAWDING FAMILY

as unacceptable for the parent to repeatedly voice words of approval to the child herself. People who grew up in another setting might conclude that this stringent behavior would be debilitating to a child's development. But this same behavior can have a different effect: one is not motivated to do things for the constant approval of others. Encouragement is given, but is more likely to be expressed in a subtle gesture than in overt praise. Self-reliance is the product. You rely on yourself for motivation, and you alone are the proper judge of your character.

This does not mean that farm people are not proud. It is a quiet pride. Some communities are proud of their high school football team. Others will point to the fact that one or more of their high school debate teams regularly moves on to national competitions. Cuming County residents are proud that their small community repeatedly produces finalists in state and national championships in 4H and FFA (Future Farmers of America), or that they recently sent a team of high school students to the National Land Judging Competition.

There is a strong sense of accomplishment in being small and doing something world class. Not necessarily to have the largest feedlots, but nonetheless to produce beef with a national reputation. Not necessarily to have the largest fields, but nonetheless to rank with the very best in bushels per acre. To produce for the world market while knowing that many of your cousins are still nearby doing the same.

To maintain a way of living, the farming way of living. This is the challenge. "Farming is a way of living, a way of living that I love," said one of my cousins, "but I can't keep that way of living and pass it on to my children if I run a losing business.

Farming is a family business, but it won't be there for my family if I don't operate it like a business."

Herein lies a dilemma. What is the farming way of living? We might assume that the man plowing behind a mule has an intimate relationship to the land. But to say that he is "knowledgeable about agriculture" might be to ignore so much about which he is ignorant. Now consider a man in the air-conditioned cabin of a tractor pulling a 24-row planter. He is out on a field alone with his thoughts. But to say that he is "alone with nature" would also be a misunderstanding—for his relationship to the land and his crops is mediated by a host of technological systems. So says James, equally expressive in voicing the joys of coming to an understanding with his fields as about the joy of running the chemical sprayer. As he makes another pass with his tractor across one of his 80-acre fields, he comments:

There's lots of technology out here on these fields. I couldn't even think about doing this if I didn't know about hydraulic systems, the new vacuum system in this planter, the electrical system, irrigation system, mechanical systems, and the computer system. To program the planter, I've got to study the printout of last year's yield, look at weather forecasts, and read reports on the performance of the latest Pioneer seeds. And that's not even talking about the business and marketing side. My dad put me to work when I was just a kid and all through high school. I helped my dad, but I didn't understand then what we were doing. I learned a lot from my dad, but now there's lots of things he doesn't understand.

What is the farming way of living?

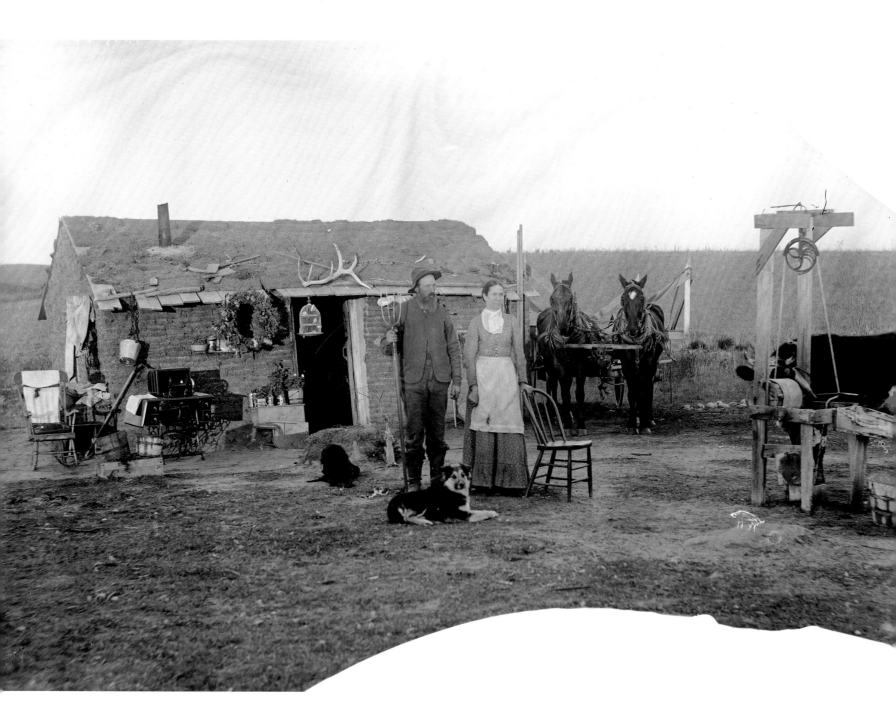

JOHN CURRY HOUSE

THE PHOTOGRAPHS

AMERICAN PHOTOGRAPHY was born with the settlement of the Great Plains. Some of the very earliest photographs that entered the national consciousness were taken just as these Nebraska farms were being homesteaded. Whereas the first generation of photographers, such as Alexander Gardner and Matthew Brady, chronicled the Civil War, later generations followed the frontier westward. Charles Van Schaick photographed the harsh aspects of family life in rural Wisconsin, while Edward Steichen traveled and took photographs in Nebraska and Colorado.

Among the early photographers was Solomon Butcher, himself a pioneer and homesteader on the plains. When he failed as a farmer, Butcher began taking photographs in Custer County, Nebraska, in 1886. With their sod houses in the background, the families posed with a farm animal or two, sometimes a dog. Butcher persuaded the homesteaders to bring objects from their sod houses out into the light, where the camera could see them. And so we see, posed with the pioneer woman, a glass, a china cup, and other treasured possessions. Taken from the cave-dark soddies and photographed in open air, these spare articles of value speak of dreams.

While Solomon Butcher's photographs portray objects in familial surroundings, Nancy Warner's photographs portray objects in abandonment. Almost 150 years after Butcher persuaded the homesteaders to pose outdoors with their possessions, Nancy goes into the decaying buildings to photograph what's left behind.

Nancy took her first photographs of Nebraska farm places in 2001. It was at a family reunion at the old Stark homestead that July. While the others were picnicking, she explored the upstairs part of the house, which was no longer occupied. She noticed that it could be interesting, and several days later she returned with her Rollei. She also took some photographs of another place just down the road.

After she returned to San Francisco and got around to printing some of the photographs, she recognized something both strange and familiar in the images that emerged. Torn curtains and abandoned cupboards, pieces of clothing, sagging doorways, shadows moving across worn surfaces—working with these images in the darkroom brought back a flood of emotions and memories. Not only of farm places she had visited as a child but also of her life growing up in Nebraska, her friends and relatives there, a way of standing in the world.

Nancy realized that these places had something to say to her, and that she could find more of them. So she began to go looking for them on her annual trips home. Using the plat maps, she roamed the country roads looking for abandoned places, traipsed through underbrush, tested rickety stairs, and made mental notes to return to a particular place at a different time of day when the light and shadows would be just right.

A pattern of wallpaper or linoleum, the slant of a staircase, the view through an open door, or the angle of an attic beam can transport us to a particular moment in time. While Nancy's photographs evoke memories for anyone with roots in the American Midwest, they also reveal the life cycle of the buildings and objects that are apart from us but are a part of our humanity.

It is true that people inhabited these buildings. But Nancy's photographs also show buildings that lived with people. Life was breathed into them. They were loved. And the proof of that can be seen exactly when they've been abandoned.

The ravishing damage of that abandonment reveals just how much these rooms were once cared for.

The very harshness of what remains, the crumbling walls and exposed beams, are a kind of archeological survey revealing this past tenderness. The many layers of plaster, paint, patching, and wallpapering are witness to moments when people loved and cared for these rooms. A photograph reveals that even a wall, with its sedimented layers peeled back, has a history. But as it charts the ravages of time, it also evokes very particular moments in that passage: "Henry, I'm going into town on Saturday to choose some new wallpaper for the dining room."

As they are abandoned, the buildings and their artifacts begin to decay. But they do not succumb immediately. Fragile yet somehow strong, for a time they hold on tenaciously. The house that refuses to be torn down. The bleeding wall. The curtain that grips the center of the window frame. The wallpaper that peels back at the edges yet still clings to life.

Midway between the photographs of Solomon Butcher and those of Nancy Warner stands the photography of Wright Morris, whose photo-texts, *The Inhabitants* and *The Home Place,* were published in the 1940s. Morris is a major source of inspiration for this book. "Where are the people?" Morris was asked by an official of the Farm Security Administration, who didn't recognize that the people were present in their stories. Inspired by the vernacular with which Morris framed his photographs, the use of photographs in this book explores the relationships between land and language that underlie the stories told by the buildings themselves.

Like Morris's photographs, Nancy's are not in the category of documentary; they are as much about light and shadow, and memory, and growing old as they are about specific farm places. Nevertheless, in some cases her photographs are all we have left of these human artifacts. As Wright Morris said, speaking about his own fiction:

> It is emotion that generates image-making: it is emotion that processes memory. . . . First we make these images to see clearly: then we see clearly only what we have made.

Finally, one other point of similarity. When he was working on his early photo-texts, Morris believed that he was recording the end of family farming. Yet, when he returned to Nebraska many decades later, he was less sure of his former conviction. With him, we share this open question.

* * *

The Stark homestead was sold while this book was in preparation. The 13 acres of the farm place remain in the ownership of our two bachelor cousins, who live there in the house where our parents were born. On the property you'll find several dilapidated farm buildings, an enormous gnarled cottonwood, a grove of smaller cottonwoods strewn with pieces of broken farm equipment, a tired old dog, and a frisky puppy.

Ferny's old house is still standing.

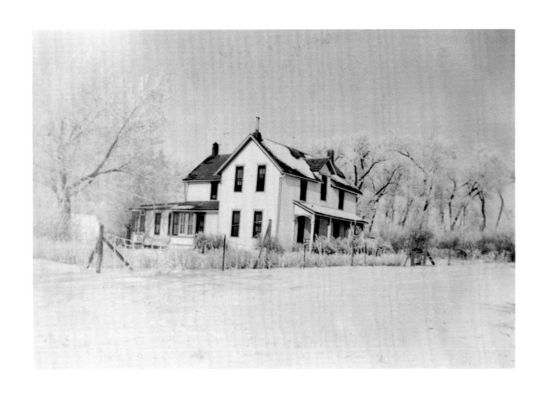

STARK PLACE,
CIRCA 1920

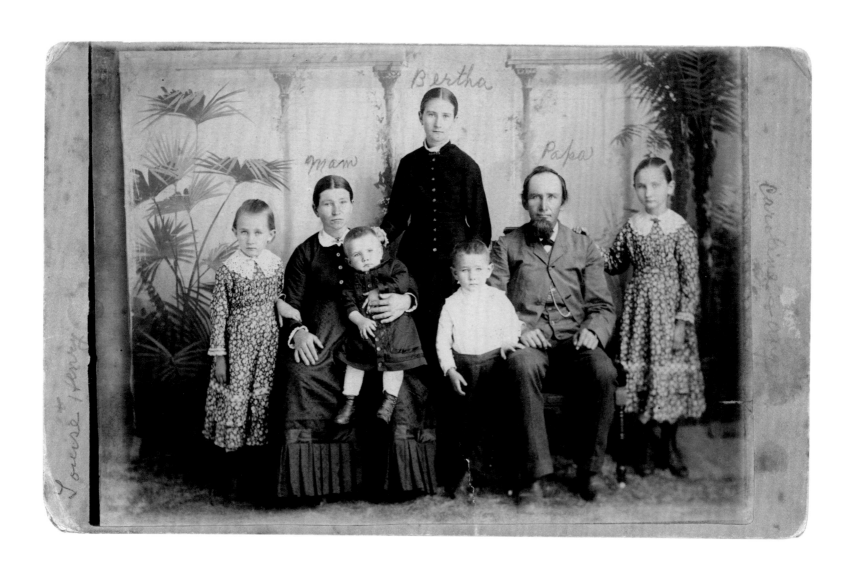

Mam Bertha Papa

AUGUST STARK FAMILY, 1887

LIST OF VOICES

Bonnie, age 79, retired; Elkhorn,
 Nebraska. Grew up in Cuming County.
Bruce, age 49, owner, Aloys Transfer, Inc.,
 and truck driver; West Point, Nebraska.
David, age 70, retired food safety inspector,
 USDA; Fremont, Nebraska.
Ferny, age 80, retired farmer;
 Beemer, Nebraska.
Gayle, age 64, farmer; Wisner, Nebraska.
James, age 25, farmer; Beemer, Nebraska.
Kathy, age 57, part-time farmer, insurance
 agent, bookkeeper for seed dealer,
 Metermax technician, owner of a restaurant
 and bowling alley, bowling coach;
 Wisner, Nebraska.
Katie, age 28, administrator;
 Lincoln, Nebraska.
Les, age 52, welder; Wisner, Nebraska.
Marian, age 69, retired farmer;
 Scribner, Nebraska.
Neil, age 54, welder; Beemer, Nebraska.
Opal, age 86, retired, Omaha, Nebraska.
 Grew up in Cuming County.
Tim, age 54, farmer and feed lot owner;
 West Point, Nebraska.

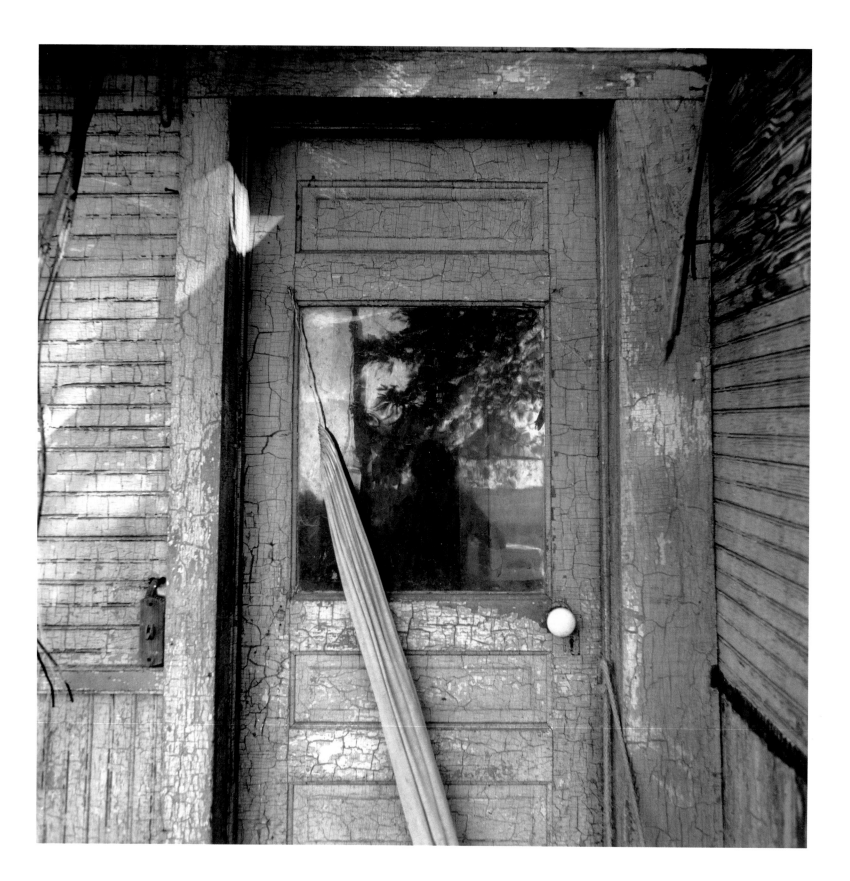

LIST OF PHOTOGRAPHS

All photographs were made with a medium-format camera
and Kodak TMAX film, and printed in a wet darkroom.
Prints were selenium-toned, but a few in the center of the book
were sepia-toned. High-resolution scans for the reproductions
in this book were made from the original gelatin silver prints.

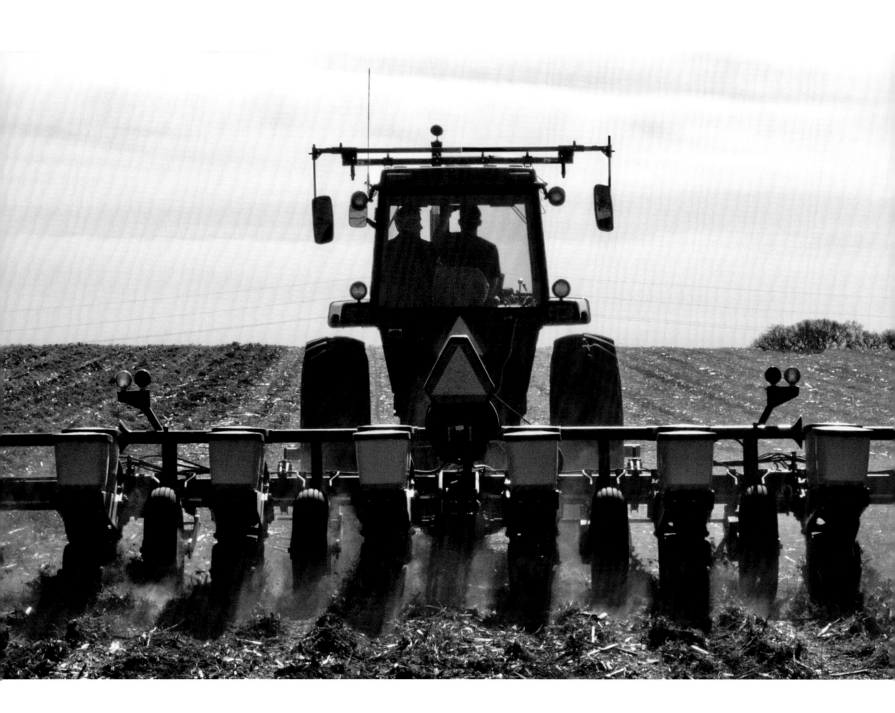

ACKNOWLEDGMENTS

DAVID AND NANCY: This book would not have been possible without the help of family and friends who opened their homes and hearts to us. We thank first our Aunt Ferny Moeller. During her many visits to Nebraska, Nancy stayed at Ferny's place, and David would begin and end his visits by talking with her there. To walk even ten minutes with Ferny on her place is to gain an appreciation of what it means for someone to have a deep and abiding affection for animals. We guess that Ferny would say there are voices missing in our book. True, we have photographs of buildings and quotations from people—but we just didn't capture the bleating of her dear goats.

We thank next our cousins on the Henry and Hildegard Stark side. Steve and Gary Stark welcomed Nancy to the Helen and Reynold Stark place. Jeff Moeller shared with us his hopes and dreams while growing up on a Cuming County farm. Dawn Gall, Donna Graybeal, Sue Schroeder, and Carol Wagner nourished us not only with delicious food but also with their ongoing questions and encouragement. Kathy Giese must be the hardest working mother and grandmother in all Nebraska. With her quick recall and quiet sense of humor, she is the best informant a sociologist could ever wish to have. Neil Stark found sites for Nancy to photograph, drove us on back roads in his pickup, and thoughtfully and patiently explained so many aspects of rural life. It didn't take us long to become aware that one phrase—"Neil Stark is our cousin"—was enough to open doors throughout the county.

Other friends and family were also generous with their time and help. Tim Schroeder spent many a conversation with us about the economics of agriculture and the technical details of modern farming. Katie Schroeder-Chatters's beautiful daughters will not have grown up on a farm, but they benefit every day from a mother who did and who can speak about that experience with such poise and grace. Cheryl Schultz helped us understand fertilizers and pesticides from the business side; Loren Schroeder did so on the farming side, along with providing an introduction to the importance of timely information in the life of a modern farmer. From Brenda Martin and Chris Ruskamp we learned about the science of seeds; Bruce Wolff

kindly told us about the history of Aloys; and with Byron Keller, David spent the better part of a day on the enormous Wisner feedlot. We're also grateful to Les Breitkreutz, Duane and Florence Breitkreutz, Gayle Giese, Jim and Barb Kanter, Marian and Vernon Koester, David Kroeger, and Bonnie Pojar for sharing their memories of farm life on the Great Plains. David will never forget his morning on a tractor talking with James Kirch.

We both have fond memories of lunch with former Poet Laureate Ted Kooser in Dwight, Nebraska (pop. 204), and of continuing the conversation in his studio there. While Ted looked at an early mockup of the book, we sat on a bench in front of his storefront sign, "Poetry Made and Repaired." We very much appreciate his support and encouragement.

At Columbia University Press, we thank Bridget Flannery-McCoy, Lisa Hamm, Leslie Kriesel, and Myles Thompson. We are especially grateful to Jim Jordan. Of all the people we worked with on this project, Jim really understood what we wanted to do in this book. At every key decision point, he was there with us to take the more challenging route. For that understanding and for his steady and consistent support, we are most grateful.

↔ DAVID: I am grateful to my wife, Monique Girard, for encouraging Nancy and me to undertake this project. In Nancy's studio in San Francisco, Monique and I were overwhelmed by the power of Nancy's photographs, and it was Monique who raised the idea that we collaborate on a book. My daughter, Alexandra Stark, quickly realized the value of a book that had not simply photographs followed by a narrative but intermingled images and voices. I'm very grateful for her feedback, especially for her keen eye and good editorial judgment on the sequencing of the photographs and text. My son, Ben Stark, took apart whole pieces of the afterword and put them back together again in a more concise and meaningful way. It was wonderful to benefit from a writer's sense of pacing and rhythm.

I am grateful for encouragement and support of this project from my colleagues and friends Peter Bearman, Nicholas Dirks, Victoria Johnson, Alondra Nelson, and Joan Robinson. I also benefited from feedback from my colleagues Peter Behrens, Lieve Joris, and Guido Golüke at The Netherlands Institute for Advanced Study, where I was in residence in fall 2012.

Nancy and I together thanked our Aunt Ferny. I would also like to thank my Aunt Opal and Uncle Milt Warner. One of the best things about working on this project was that I got to see Opal and Milt more often. Milt has a quiet love of life and, like his laugh, it is infectious. It's not a laugh, actually, more like a chuckle that rolls right along, keeping the jokes moving and the stories flowing, as when he got together once with Roy Sells. Roy has to be one of the greatest storytellers alive, but with Milt as straight man, the combination, over a long and hilarious evening, was deadly dangerous.

If Aunt Ferny was our number one informant, Aunt Opal was our number one supporter and tireless advocate. She talked with us about the project, she helped think about people we could meet, and she would sometimes come along to help get the conversation going. Opal would often come with us out to Ferny's place, as on the occasion when I discreetly recorded her, Nancy, and Ferny as they were looking through a box of photographs.

My deepest gratitude is to Nancy Warner for inviting me to join her in this venture. Nancy had taken almost all of the photographs for this

book by the time we started working together. But I was able to spend some time with her as she photographed at several abandoned farm places. These opportunities, and our conversations while making decisions about the sequencing and layout of the images and text, meant that my knowledge of the art of photography went up a very steep learning curve.

Many of the sites where Nancy photographed are thickly overgrown with brush and trees and vines, sometimes entangled through doors and window sills. I was able to observe how Nancy navigated these. There was considerable care required—for there was a not inconsiderable danger that these dilapidated structures could collapse. One mid-morning, after much effort, we were able to stand at the window of a corn crib. I gazed in, and seeing the light striking between the slats, exclaimed, "Nancy, it's so beautiful." Without missing a beat, Nancy said, "Let's come back around 4:30. The light will be much better then." At that point I realized that each of these photographs must have a similar story: finding just the right moment to be taken, just the right exposure, just the right work in the darkroom, just the right cropping, just the right resolution in the scans, and so on.

Nancy was also quite involved in the afterword. I enjoyed reading early versions of the various sections to her, sometimes only moments after their drafting at the Super 8 Motel in West Point, Nebraska. I'm grateful to Nancy and her husband, Sean, for making suggestions and comments. But most important is simply to say that we had so much fun together—driving the county roads, having coffee in little one-restaurant towns, talking about the photographs, talking about talking to people, experimenting with various architectures for the book, revising, the list could go on and on—you name it, we enjoyed it. Thanks, Nancy, it was so wonderful working with you.

↪ NANCY: I didn't realize at the outset of this project how deep my connection is to the place where I grew up, or how making the photographs would bring me closer to the people there.

My gratitude to my mom and dad, Opal and Milt Warner, and my sister, Sandy Smith, goes way deeper than thank you. You're always there, no matter what.

My husband, Sean, and our son, Colin, have been part of the project every step of the way. Nothing that I've written would be as clear and succinct without Sean's help. Colin has looked at my prints his entire life, but this series got extra attention. I appreciate his clear eye and visual sense in the editing process. I can count on both of them for an honest and fresh response, even if it's not what I want to hear.

The other people I wish to thank fall into three groups.

First, those who were instrumental during the making of the photographs:

I loved spending time with my mom and Aunt Ferny in the countryside where they grew up. They encouraged me, fed me, eagerly awaited my return at the end of each day to find out where I'd been, and told me stories while we looked through family albums.

Thanks to my sister, Sandy, and our friend Colleen Hendrick (née Herchenbach), who drove me all over western Iowa looking for abandoned farmhouses. Colleen invited me into her family home on several occasions to photograph. Susan and Paul Christofferson allowed me to photograph on the Christofferson place. Bruce and Sue Wolff left the door of Aloys Store unlocked so that I

could enter anytime. Karen and Gerry Schutte suggested the Vollmer place and were generous in many ways to Aunt Ferny, my mom, and me. Tina Kunka "talked me back" when I got hopelessly lost. I'm grateful to Reece Summers, then curator at the Great Plains Art Museum, for giving me hope that others might see something in what I was doing.

Second, for help with the exhibitions:

Thanks to Amber Mohr for her interest and belief in my work, as well as her sure-handedness in planning and installing the first exhibit at the Great Plains Art Museum; and to Linda Ratcliffe, Kim Weide, and Amanda Mobley-Guenther for their help with that exhibit.

My husband, Sean, spent countless hours helping me curate the exhibits and frame and pack the prints. The exhibits would never have happened without my Nebraska crew on the ground. My sister and brother-in-law, Sandy and Roger, were there for every installation and deinstallation. I consulted with Sandy on aesthetic decisions and relied on Roger to coordinate transportation. My mom and dad were always there to help out. Dad loves a good technical problem and worked out a number of installation and transportation solutions. Colleen and Mike Hendrick were also generous with their time, helping to produce each show. Mike and Roger put heroic efforts into moving the large boxes of prints from place to place. Thank you to all these and others in our extended families who helped me hang and publicize the shows.

Thanks to Pam King and volunteers at Gallery 92 West, Fremont, Nebraska, for a great reception, and to the volunteers there for gallery sitting; and to Tammy Greunke, Chris Bristol, and others in the community who drew attention to the show.

Thanks to those who helped make the exhibit at Norfolk Arts Center a huge success. This exhibit included installations of antiques, household objects, and artifacts throughout the gallery. The following people loaned items for display: Chase Becker, Shavonne Breitkreutz, Marie Burger, Susan Christofferson, Dawn Gall, Kathy Giese, Donna Graybeal, Colleen Hendrick, David and Naomi Kroeger, Alex Meyer, Ferny Moeller, Gregg Moeller, Sandy Smith, Carol Wagner, Opal Warner, and Ruby Wooten. Additional thanks to the NAC staff, Kara Weander-Gaster and Chris Rempe, for all their work; board member Jody McQuillan for her help with the memory booth; J. Paul and Eleanor McIntosh for sponsoring the exhibit; Sheryl Schmeckpeper and Mark Ahmann for helping get the word out about the show; and the NAC ladies for cooking and serving fabulous food at the reception.

Third, for help with this book:

Thanks to Monique Girard for the insight that David and I would make a good team; and to Sean, Colin, and Jon Hsy for their keen editorial eyes.

The stars and planets must've been lined up just right that day in San Francisco when David and I decided to collaborate on this book. There followed lots of phone calls and Skype talks to discuss what the book should be. In the beginning, I wondered how he could possibly manage yet another project in his already challenged schedule, but I soon recognized his amazing ability to focus on the subject at hand. I had his complete attention when we met or talked, and we always got lots done.

I cherish my memories of our time together in Cuming County: driving around to meet with people, drinking weak coffee, and having long conversations at the Super 8 breakfast table or

over dinner at the local diner. During the days, we stood around in yards and fields, sat at kitchen tables, rode in pickups and on tractors, talking nonstop. The time in between and back in our car, David would whip out his notebook and make notes while we headed for our next destination. I loved being able to introduce him to a few of my favorite places. We scrambled through underbrush and ducked under tree branches to get to the old ruins. In the evenings at the Super 8 he read me his notes from conversations, and later drafts of the afterword. Many times and in multiple cities, we laid out copies of photographs and text to work out the structure and sequence of the page spreads. All our visits were intense and rich experiences for me.

Finally, thanks to all those who directed me to places of interest, and those who viewed the exhibits, bought prints, or shared their memories and stories with me.

The piece by Ted Kooser that I refer to in the preface, "Small Rooms in Time," is from *The Best American Essays 2005,* ed. Susan Orlean and Robert Atwan (Mariner Books, 2005). The title of this book comes from a poem by Nebraska State Poet William Kloefkorn (1932–2011), "Nebraska: This Place These People," in *Not Such a Bad Place to Be* (Copper Canyon Press, 1980). His poems and memoirs capture the pain and pleasure of growing up in Nebraska. Sometimes they make me laugh out loud.

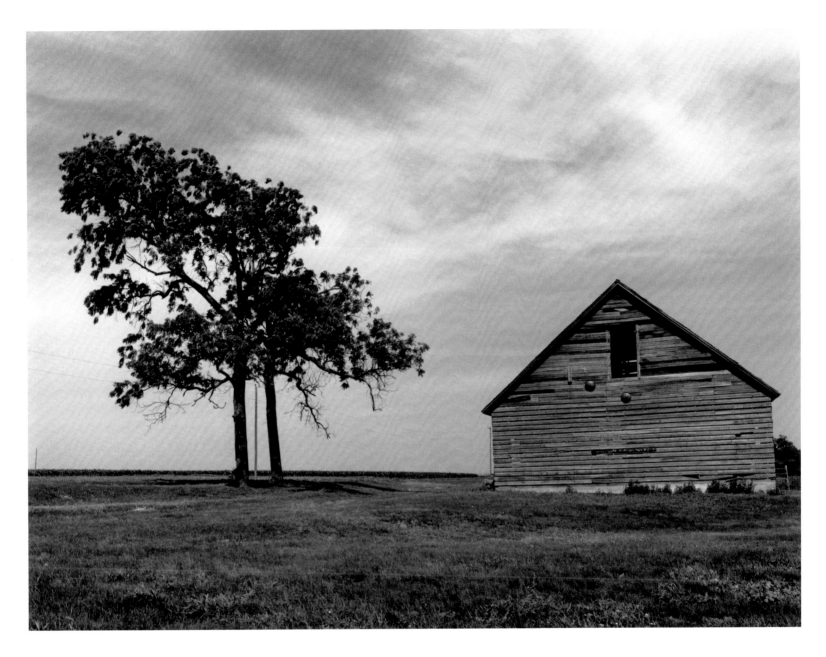

I had lived with the idea of change, had seen it as a constant,
had seen a world in flux, had seen human life as a series
of cycles that sometimes run together.

Land is not land alone, something that simply is itself.
Land partakes of what we breathe into it,
is touched by our moods and memories.

—V. S. NAIPAUL, *The Enigma of Arrival*

. . . for the past is never closed down and receives
the meaning we give it by our subsequent acts.

—CZESLAW MILOSZ,
"What I Learned from Jean Hersch"
Selected Poems, 1931–2004